GRANITE, WATER,
AND LIGHT

GRANITE, WATER, AND LIGHT

The Waterfalls of Yosemite Valley

Photographs and Text by Mike Osborne

Yosemite Association, Yosemite National Park, California
Heyday Books, Berkeley, California

Library of Congress Cataloging-in-Publication Data

Osborne, Michael.
 Granite, water, and light : the waterfalls of Yosemite Valley / photographs and text by Mike Osborne ; Yosemite Association, Yosemite National Park, California.
 p. cm.
 Originally published: Yosemite National Park, Calif. : Yosemite Natural History Association, 1983.
 ISBN 978-1-59714-099-7 (pbk. : alk. paper)
 1. Waterfalls--California--Yosemite National Park. I. Yosemite Natural History Association. II. Title.
 GB1425.C2O83 2009
 551.48'40979447--dc22
 2008023789

Cover Photograph: Ribbon Fall
Book Design: Lorraine Rath
Printed in China by Everbest Printing Co. through Four Colour Imports, Ltd., Louisville, Kentucky

This book is the result of a collaboration between the Yosemite Association and Heyday Books. You can find information about the Yosemite Association at www.yosemite.org, or write to P.O. Box 230, Yosemite National Park, CA, 95318, or call (209) 379-2646. Orders, inquiries, and correspondence about this book should be addressed to:
 Heyday Books
 P.O. Box 9145, Berkeley, CA, 94709
 (510) 549-3564, Fax (510) 549-1889
 www.heydaybooks.com

10 9 8 7 6 5 4 3 2 1

CONTENTS

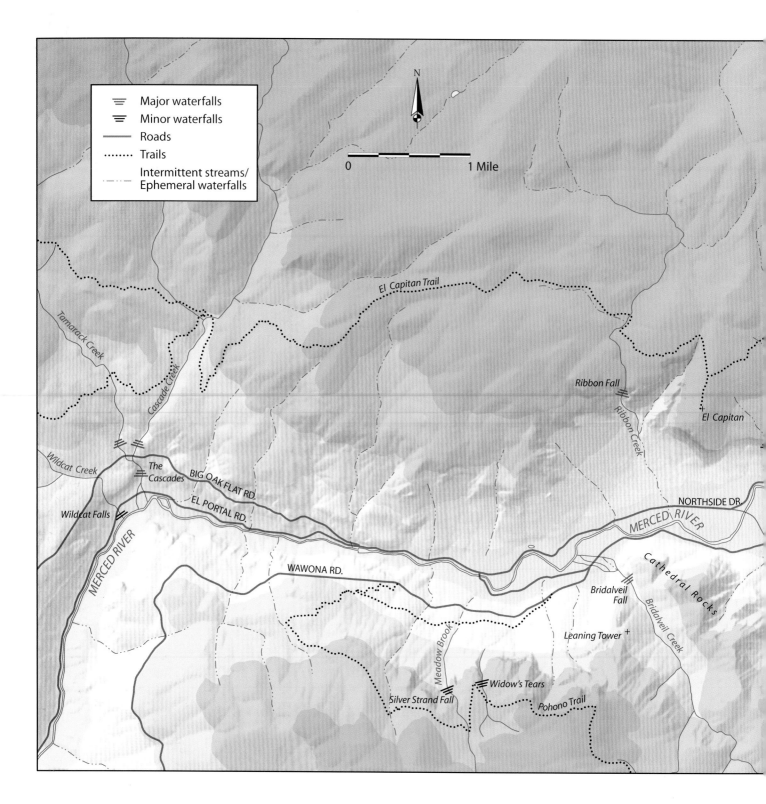

Major waterfalls
Minor waterfalls
Roads
Trails
Intermittent streams/
Ephemeral waterfalls

N

0 1 Mile

Tamarack Creek

Cascade Creek

El Capitan Trail

Ribbon Fall

Ribbon Creek

El Capitan

Wildcat Creek

The
Cascades BIG OAK FLAT RD.

Wildcat Falls EL PORTAL RD.

NORTHSIDE DR

MERCED RIVER

MERCED RIVER

WAWONA RD.

Cathedral Rocks

Bridalveil
Fall

Leaning Tower

Bridalveil Creek

Meadow Brook

Silver Strand Fall

Widow's Tears

Pohono Trail

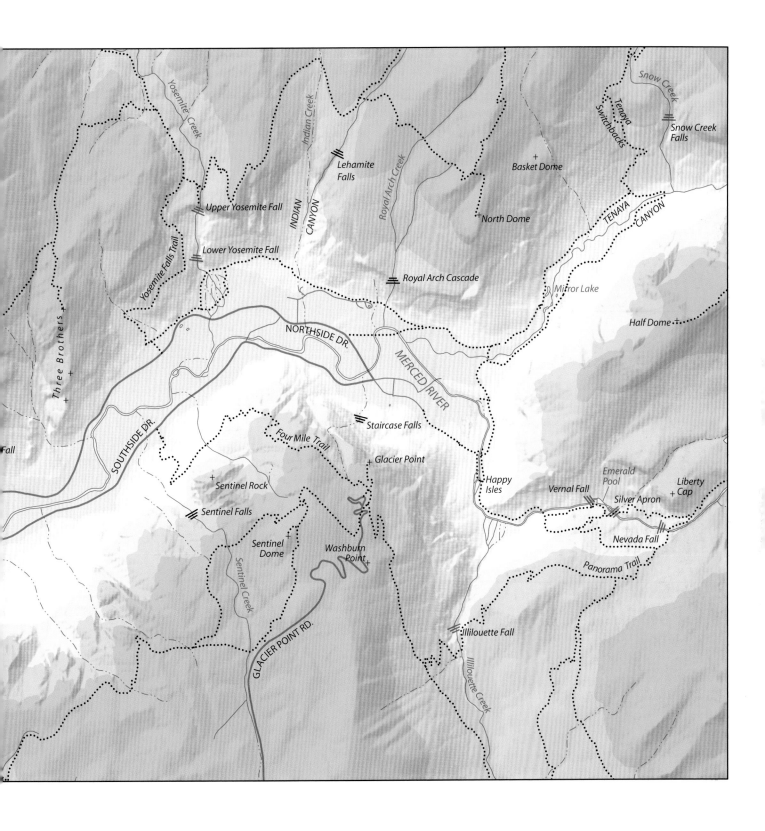

INTRODUCTION

What is it about waterfalls? Next to the immensity of Yosemite Valley, its most striking feature is the wondrous array of foaming waterfalls, leaping over perpendicular granite walls in dazzling ribbons of light. The Valley owes much of its renown to their number, diversity, and size.

Each is a unique combination of granite, water, and light. Water from melting snow collects in drainage basins of many sizes, to flow to the Valley's rim where the form of its falling is a statement of the underlying structure of the granite. Light is the medium through which we perceive these wonders, for whether one looks through a camera or the lenses of one's own eyes, light alters the appearance of each waterfall, throughout the course of every day and year.

Previously, little attention has been given to Yosemite's minor waterfalls. One objective of this book is to provide the reader with an overview of the Valley's lesser known falls and the numerous springtime ephemeral cascades of outstanding, though short-lived, beauty.

Many would agree that Yosemite National Park has the grandest assemblage of waterfalls in the world. There are many great falls, some more awesome than Yosemite's in terms of water volume—Niagara Falls, Victoria Falls in Africa, and Iguazu

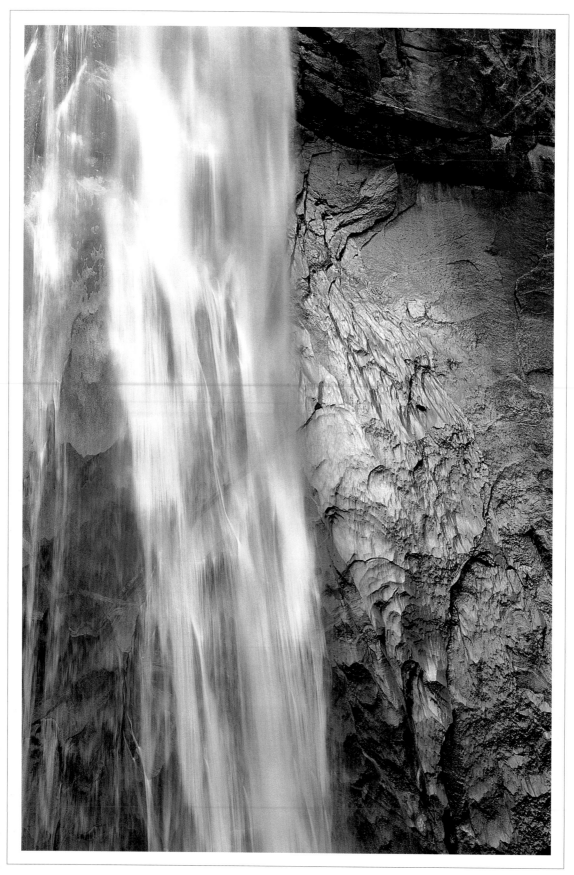

Water-sculpted rock, Illilouette Fall

Falls in South America come to mind. Others are wonderfully high and free leaping; Angel Falls in Venezuela is as beautiful as any fall in Yosemite (and about twice as high as the Upper Yosemite). But what Yosemite lacks in the flow of Niagara or the record height of Angel is more than made up for by the variety and number of waterfalls here. There are uncounted scores of incredible waterfalls and cascades in the park, and many of them are impressively tall. There are so many that this book must restrict itself to the falls in Yosemite Valley, which contains the greatest concentration of, as well as many of the most spectacular, falls in the park.

Judging from the numbers of people who gather at the popular waterfall observation points in Yosemite, it is clear that visitors appreciate the many superlative qualities of falling water. Their interest may be due in part to the endlessly fascinating motion of the water drops as they gather in plummeting comets of spray, falling apart and reforming continuously until dashing onto the rocks below. Or it may relate to feeling the cool, bracing spray so enjoyable on a hot summer day, or perhaps the calming humidity and soothing negative ions splashed into the air at the base of a waterfall. Others may be attuned to the endless symphony of sound. If you listen carefully, waterfalls really are music to the ear. Each has its own distinct song, which is influenced by variables including wind, water volume, height, amount of contact with the cliff face on the way down, and location of the listener. An interesting experiment is to pay close attention as the changes in your position alter the music of a waterfall. Some people have observed that the song is more subtle and enjoyable when a fall is at a lower water volume— the roar of high water often masks the nuances that can exist later in the season.

For yet other visitors, the primary attraction is the almost guaranteed (as long as the sun is at your back) rainbow tied to a waterfall. The volume of the spray and the minute size of the water droplets can

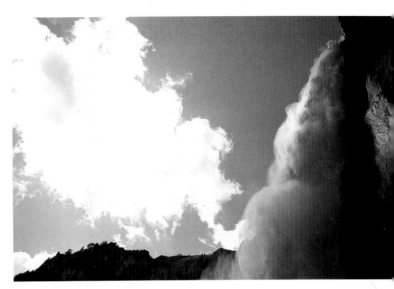

Upper Yosemite Fall and cloud

create quite a spectacular sight, and being able to watch spray fly across the background of a waterfall and through the prism of a rainbow can be very enchanting, especially if you watch long enough to see the orientation of the rainbow to the waterfall change with the position of the sun.

Especially sublime creations of the natural world (and the waterfalls of Yosemite Valley certainly qualify) often generate feelings and emotions akin to spiritual serenity or joy. The memoirs and diaries of many early visitors to Yosemite are replete with references to how the beauty before them engendered a sense of reverence, and the same is no doubt true today. For others, that same sense of wonder and awe is enhanced by scientific understanding; advances in geology may provide some people with an even deeper measure of appreciation for the amazing spectacle of falling waters in Yosemite.

And speaking of enhancing our appreciation, one of the great unknown secrets to adding visual impact and pleasure to a trip to Yosemite is to bring along a pair of binoculars. Many people only think about using binoculars to view distant objects, but they can also be used to enhance falls that are

License plate spotted in Yosemite Valley

closer, providing a more active and intimate connection between the viewer and the spectacle. The increased magnification can also help you highlight particularly interesting segments of the fall as well as elements of the background cliffs. There is just something elemental and more engaging about using binoculars. Besides, it's just plain fun!

The Human Connection

Waterfalls tend to be outstanding natural features in all countries and cultures and are frequent tourist destinations wherever they are found. Undoubtedly, the importance of waterfalls to humanity has been true throughout history. Because waterfalls are so interesting and engaging to people, it would be helpful for our study and review to see what others from the past have said about the ones in Yosemite Valley.

Before we hear what early observers had to say about Yosemite and its waterfalls, however, let us recognize the people who first knew the region, long before explorers and travelers starting writing home about the Valley. For thousands of years Native Americans dwelled in this beautiful and well-hidden sanctuary, which they called Ahwahnee. The cultural identity of the original inhabitants is controversial— both Mono

Lake Paiutes and Southern Sierra Miwoks have ties to the area—but what is certain is that much of their history was lost in the wake of disease, invasion, and forced relocation, all of which resulted from the arrival of Europeans to the area, particularly those who came as part of the 1848 gold rush. Precious little is known about their cultural beliefs concerning the incredible landscape of their Yosemite home. Previously published Indian legends undoubtedly contain authentic elements, but it is impossible to distinguish truth from romantic exaggeration. Only tempting fragments remain of the Indian names of waterfalls, and even those are shrouded in uncertainty. We are therefore forced to pick up the story of the falls after the expulsion of the Yosemite Indians, and we can only imagine the cultural wealth that has been lost.

Clockwise from top left: Lafayette H. Bunnell, James M. Hutchings, John Muir, Francois E. Matthes. Courtesy Yosemite National Park Museum.

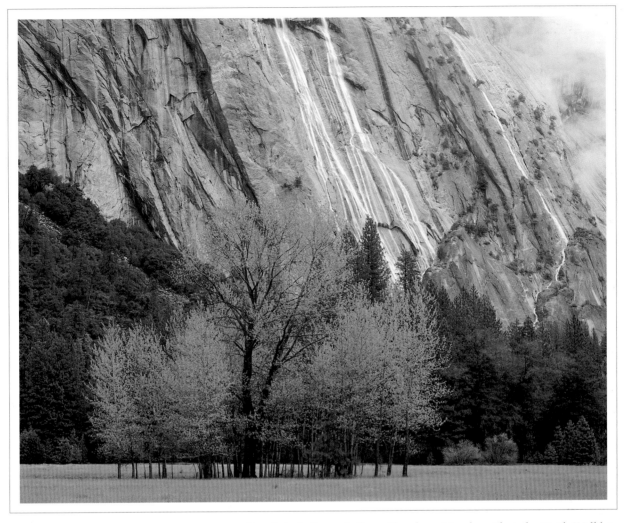

Royal Arch Cascade from Ahwahnee Meadow. Photo by Keith Walklet.

Although much has been written about the waterfalls since the first tourist party arrived in the Valley in 1855, a lot of it is too flowery and not very good; after all, there are only so many superlatives. Anyone who has ever tried to write a postcard to the folks back home describing the majesty and magnificence of the falls knows how hard it is to do them justice. Fortunately for us, however, not everyone has been caught speechless. I have chosen four eloquent spokesmen from Yosemite's past to attend us on our tour of the Valley's waterfalls, and in addition to being able to "turn a phrase," each

plays an important role in the history of Yosemite as well. We will rely heavily on the observations and descriptions of the waterfalls provided by these writers because they are the best available.

One of the men who will guide us through this book actually came in contact with those early Native peoples we know so little about. Dr. Lafayette Bunnell arrived in Yosemite in 1851 with the Mariposa Battalion, the first group of non-Indian people to enter the Valley. Although the battalion was a volunteer army formed to capture and remove the Indians from the area,

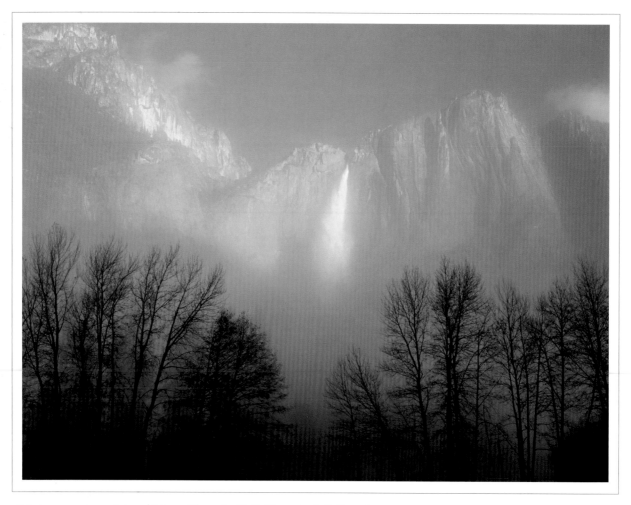

Winter morning mist and Upper Yosemite Fall. Photo by Jeff Grandy.

Bunnell himself attempted, with limited success, to learn the Indian names and meanings of waterfalls and other prominent geological features, thus preserving some of our meager knowledge about the original inhabitants. On the soldiers' first day in the Valley, about March 21, 1851, Bunnell proposed giving it "the name of the tribe who had occupied it; that by so doing, the name of the Indians leaving their homes in this valley, perhaps never to return, would be perpetuated." That name was Yosemite.

Although Bunnell was inspired by the magnificent scenery the battalion had "discovered," and although returning soldiers must have relayed stories about the Valley to residents and miners in Mariposa County, gold took precedence over scenery in those feverish times, and descriptions of the Valley were generally regarded as grossly exaggerated and no one paid much attention. It was not until 1854 that Yosemite, with its "thousand foot waterfall," was mentioned in the *Mariposa Chronicle*; that account followed the story of a second military expedition pursuing Indians into Yosemite in 1852 and only mentioned the fabulous scenery in passing.

One man who was not immune to the charms of Yosemite was James M. Hutchings, the editor and

publisher of *Hutchings' California Magazine*. In the summer of 1855, Hutchings, lured by reports of the fabled waterfall, organized the first tourist trip to Yosemite in search of material for his periodical; traveling with him was artist Thomas Ayres, who had been engaged to provide sketches of the Valley. The resulting articles and drawings at last brought Yosemite's wonders to the attention of the rest of the country and the world. First a trickle, and then a flood of tourists came to see the Valley and its extraordinary waterfalls.

Hutchings was quick to realize the financial potential of catering to the tourist trade and soon moved to the Valley and opened a hotel. Relying on an Indian employee for information, he published his own interpretations of the Indian names of the features and falls of Yosemite. He also began christening features with English names, often to popularize, and even romanticize, the Valley. Hutchings's fame grew with each publication, and he became increasingly identified with Yosemite. Meanwhile, Bunnell was discovering that Hutchings's interpretations and definitions of the Indian words and names for Valley features differed markedly from what he had learned when he arrived with the Mariposa Battalion. This prompted him to write his own account, *Discovery of the Yosemite*, which was not published until 1880, almost thirty years after his original visit. While both men made valuable contributions to our knowledge regarding Indian life in the Valley, neither had anything resembling a complete picture of the native culture, and even the authenticity of their sources is in question.

Hutchings and Bunnell were not alone in the contest to name the Valley's attractions. Other early visitors, also vying for the privilege of christening a waterfall, offered suggestions, hoping that public opinion and time would solidify their choices. As a result, many of the waterfalls had a succession of names or even several at one time.

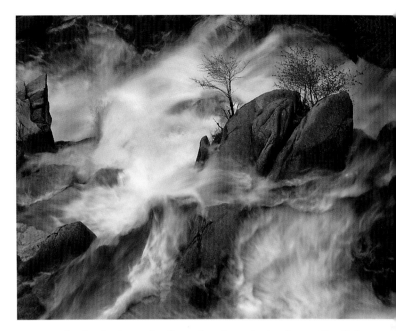

Cascade Creek above the Cascades, from the bridge on Big Oak Flat Road. Photo by Charles Cramer.

Books, magazine articles, sketches, and photographs published by early residents and visitors all served to advertise the wonders of Yosemite. In 1864, as a result of the efforts of a small group of dedicated conservationists, the U.S. Congress and President Abraham Lincoln set aside Yosemite Valley and the Mariposa Grove of Big Trees as a state-managed preserve "for public use, resort and recreation...inalienable for all time." During the 1870s it became apparent to many, including mountaineer John Muir, that the preserve should also include the drainages forming the Valley waterfalls as well as Hetch Hetchy Valley and its watersheds. Muir's eloquent prose describing Yosemite's magnificence, and the need to protect it, attracted a national following, and as spiritual head of the American conservation movement and founder of the Sierra Club, he was instrumental in the process that culminated in 1890 with the establishment of Yosemite as a National Park, which included the watersheds for both the Tuolumne and Merced Rivers.

By early in the twentieth century, Yosemite's fame had spread far and wide and there arose a public clamor to settle the question of the origin of Yosemite Valley and its wondrous waterfalls. In 1913, the U.S. Geological Survey selected a giant in the new field of geology, Francois E. Matthes, to determine how the Valley was formed. After many seasons of fieldwork, Matthes published his findings describing the creation of Yosemite Valley. Matthes was a truly remarkable man; although a respected scientist, he had the heart and soul of a poet, and his writing is replete with appreciation for the wonder and beauty of Yosemite Valley. In some cases his eloquence is equal to Muir's in describing the beauty he saw.

Bunnell, Hutchings, Muir, and Matthes are some of the most expressive writers who have described Yosemite's wonders, and each occupies a significant place in the written records of Yosemite's waterfalls. To Bunnell went the distinction of being among the first white men to see them and the honor of naming many. From his writing it is clear that Bunnell approached Yosemite's grand scenes with religious fervor—here was God's handiwork made manifest. Hutchings was the first "tourist" to make the then arduous journey to Yosemite, and, in his unofficial role as "Valley Guide," he introduced the waterfalls to the world. Although he viewed the splendor of the scenery with wonder and reverence, he was not so enthralled that he did not recognize the good living to be made promoting nature's grandeur.

Muir's powers of observation and his graceful style and fluent pen enabled him to see and to communicate the essence and character of the falls more perfectly than anyone before or since. To this day, his is the crowning achievement in the written word describing Yosemite's waterfalls and other noble features. His capacity to articulate the joy of waterfall-watching has given innumerable visitors the framework to understand and express their own emotional responses to the falls. In Muir, the euphoria coursing through his writing seems somehow more spiritual, and thus more contemporary, than the piety expressed by other early writers.

Lastly, Matthes was able to meld artistic sensibility with scientific comprehension. He was truly a Renaissance Man who applied his intellect to the question of Yosemite's creation. To him belongs posterity's gratitude for laying the groundwork for understanding the geological forces that created Yosemite's amazing collection of falling waters. And with our gratitude goes our appreciation that he was able to do it so eloquently in the process.

These four men will attend us on our tour visiting the waterfalls of Yosemite Valley and provide colorful descriptions of the scenes before us that are just as appropriate and meaningful as when first written.

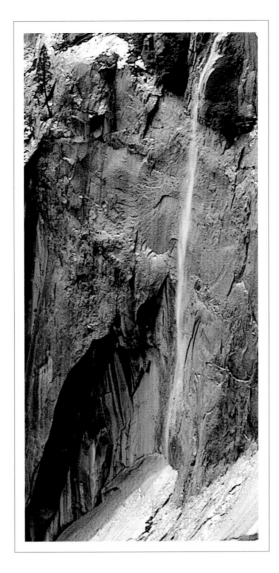

THE GRANITE

If Yosemite Valley's reputation as the world head-quarters for waterfalls is due to the majesty and diversity of its collection, the obvious question is how, and why, the Valley is so blessed. Not surprisingly, the answers to these questions are inextricability intertwined with the geologic developments in Yosemite over the past many millions of years. A brief overview and basic understanding of the geological processes at work in the creation of Yosemite Valley's waterfalls will enlighten our discussions as we look at each of them in turn.

Living as we do in an age of science, information, and technology, it is easy to forget how poorly the structure and evolution of the Earth were understood during the last half of the nineteenth century, when Yosemite was discovered and became a tourist attraction. During those early years, scientists and visitors alike speculated about the processes that had adorned Yosemite Valley with its lofty, swaying waterfalls. In 1865, only ten years after the first tourist party arrived in Yosemite Valley, Josiah D. Whitney, the California State Geologist, published his theory that the Valley had been created by the dislocation of a great block of the Earth's crust; he believed that convulsive movements within the Earth during the upheaval of the Sierra Nevada Range had caused the bottom to drop out of the Valley. This process, called subsidence, had also produced the

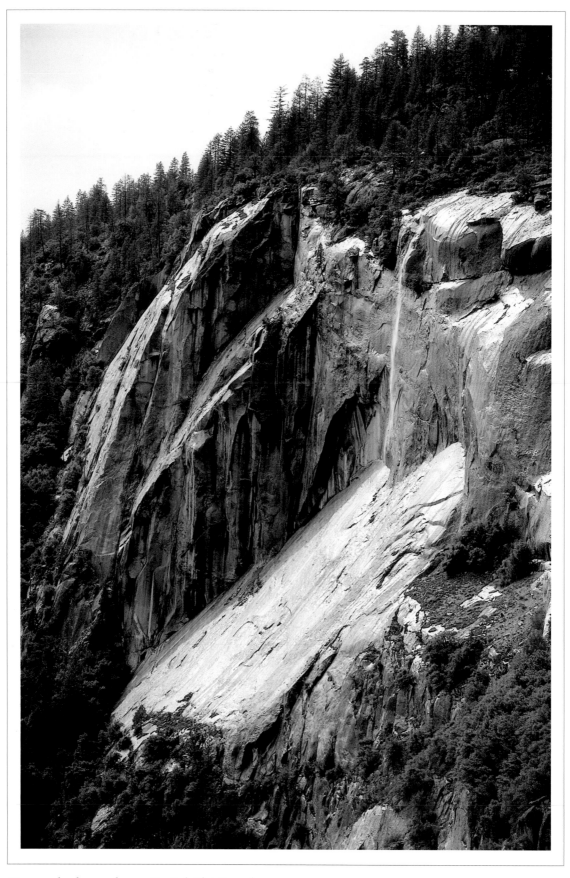

Unnamed ephemeral near Big Oak Flat Tunnel

Lake Tahoe Basin to the north of Yosemite. Whitney recognized that glaciers had existed in the Sierra but, because of the paucity of direct glacial evidence in the Valley itself, he discounted their importance here.

Another early theory of the Valley's creation was that proposed by naturalist John Muir, who arrived in Yosemite in 1868 and, having arranged his life to allow ample opportunity to explore the high country, developed an intimate knowledge of the region. From observations gathered during his ramblings, Muir became the first to understand the influence of ice in the sculpting of Yosemite. In general, Muir was right about the role of glaciers in the history of the Valley, but in some particulars he overestimated their impact. For instance, he maintained incorrectly that the Valley was the product of a single glacier. He also believed that the entire Sierra, all the way down to the foothills, had once been covered in ice. At this time, the "Great Ice Age" was still a new and vaguely understood concept, and the process of glacial erosion was poorly understood, and so, to many geologists, Muir's claims seemed extravagant.

The disagreement between Whitney and Muir generated further interest in understanding the creation of Yosemite Valley, and for the next half-century, geologists offered a wide variety of possible explanations. Most of the newer theories discounted the notion that the Valley was created in a single catastrophic down-faulting event in favor of the idea that both water and ice, working over an unimaginably long period of time, had sculpted it. Still, these theories differed markedly on whether preglacial stream erosion or glacial excavation was the primary process involved.

In the end, it was Joseph LeConte, professor of geology at the University of California, whose ideas were most nearly correct. Although impressed by Muir's glacial evidence—in 1871 Muir actually discovered the now melted Merced Peak Glacier—LeConte nevertheless attributed a considerable

share of the excavation of the Valley to preglacial stream erosion courtesy of the Merced River. (He also observed that any theory of the Valley's formation must take into account the observed tendency of the local rocks to fracture vertically. This process will be discussed in detail later in this chapter.)

The story was to remain confusing and contradictory until 1930, when Francois E. Matthes published his treatise, *Geologic History of the Yosemite Valley*, a classic of geological literature that contains a wealth of information on the glacial evidence in Yosemite Valley and the surrounding area. Matthes concluded that much of the present depth of the Valley was achieved by preglacial stream erosion of the Merced River and that the ultimate excavation was accomplished by glaciers, the deepest occurring near the head of the Valley and in Tenaya Canyon. While some of his statements have been revised in light of more recent geological research, many of his conclusions have stood the test of time.

Matthes's work accomplished much: not only did it put into perspective the Whitney-Muir debate, but his power to express complex ideas eloquently and articulately inspired general interest in geology and Yosemite, and his accurate and plentiful observations have guided and assisted geologists working in Yosemite since that time.

One of the geologists who helped update and refine many of Matthes's conclusions was N. King Huber, another geologist for the United States Geological Survey. Huber studied the Sierra and Yosemite for much of his career, and in 1987 he published the most recent synthesis of current geologic knowledge regarding Yosemite. Huber's book, *The Geologic Story of Yosemite National Park*, is written for the layman and easily understood by anyone seeking a comprehensive overview of the natural processes that were, and still are, at work in the creation of the stunning terrain. While it is not the purpose of this volume to recount the geologic history of the park, a broad outline of that story—especially as it pertains to understanding

El Capitan and Horsetail Fall

the formation of the waterfalls—is necessary to give the reader a better comprehension of the majesty of Yosemite's falls. Those wanting a more complete appreciation of the whole picture are referred to Huber's book.

As Huber points out, Yosemite owes its scenery to the emplacement of granitic rock under the area that would eventually become the Sierra Nevada. For a span of perhaps 130 million years, giant balloons of molten rock called "plutons" bubbled up from the interior of the Earth and slowly cooled beneath the surface of what is now the Sierra Nevada. The range is composed of hundreds of these plutons, each representing separate episodes of intrusion and solidification, and all of which are considered "granite" even though they differ somewhat in composition and texture.

Then, beginning about 25 million years ago, driven by tectonic stress on the western edge of North America, the Sierra Nevada began its spectacular growth. The mountain-building forces along the crest at the eastern edge of the range caused the land to gradually acquire an appreciable slant toward the southwest. Continued uplift has produced a mountain range four hundred miles long and fifty to eighty miles wide with a steep and dramatic eastern escarpment, a gentle western slope, and many 12,000- to 14,000-foot peaks.

Although gentle, the increasing slope of the land gave the rivers of the Sierra greater speed and power to cut ever-deeper canyons into the bedrock. As erosion increased with the elevation of the range, more and more of the ancient rock that lay above the buried granite was stripped away, eventually

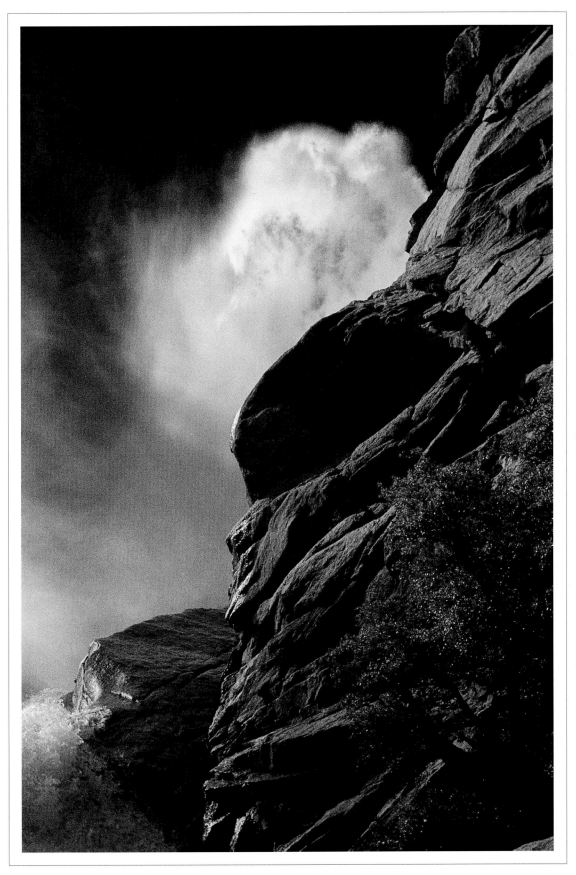

Waterwheel on Snow Creek Falls

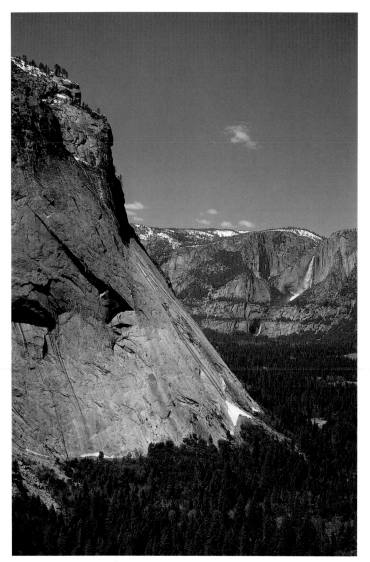

Yosemite Falls, showing prominent horizontal joints marking the base of Upper and the top of Lower Yosemite Fall (the Glacier Point Apron is in the foreground)

effective in eroding their streambeds. Also, since the tributaries generally flow north or south, at right angles to the increasing western slope of the range, their speed (and channel-cutting ability) was not significantly increased by the westward tilt of the land. As a result, the river cut its valley deeper and deeper and at a much faster pace than the tributaries eroded their channels. This left the tributary valleys "hanging" at greater and greater heights above the Valley. As the Valley itself deepened, waterfalls began to appear on the scene. There were no "leaping" falls, but from the mouths of the tributary valleys tumbled gleaming cascades as the creeks rushed to join the river below.

During the Ice Age, which began between one and two million years ago, the climate of the Sierra Nevada was much cooler than it is today. Colder temperatures were intensified as the range grew to increasingly higher elevations, and more snow fell in the longer winters than melted during the relatively cool summers. Snowfields hundreds of feet deep accumulated on the higher reaches of the range and compacted into massive glaciers. Grinding its way down the river valley, the Merced Glacier replaced flowing water as the primary erosive agent and, typical of glaciers, was much more effective at changing the landscape. Ice is better able to pluck and quarry where rock is fractured and is more powerful than water in transporting the fragments down the canyon.

Studies indicate that there were at least three major periods of glaciation in the Sierra, during each of which individual glaciers likely advanced and retreated many times. The first of these episodes, around a million years ago, is called the Sherwin period. It was by far the most extensive of the three. During this time glaciers filled the Valley, and with each invasion the advancing ice removed more rock, essentially excavating the land into what we see today. Glacial cutting transformed the steep V-shaped canyon slopes into nearly vertical rock walls and turned the earlier tributary

exposing the underlying granite over most of the Yosemite region. It should be emphasized that stream erosion of granite bedrock is a slow business. Most of the actual work only occurs in the brief periods of high water or floods, when increased water volume is capable of pushing large boulders that scrape and smash against the stream channel.

While the Merced River was busy cutting a deep canyon, its tributaries, fed by smaller watersheds and therefore containing less water, were not as

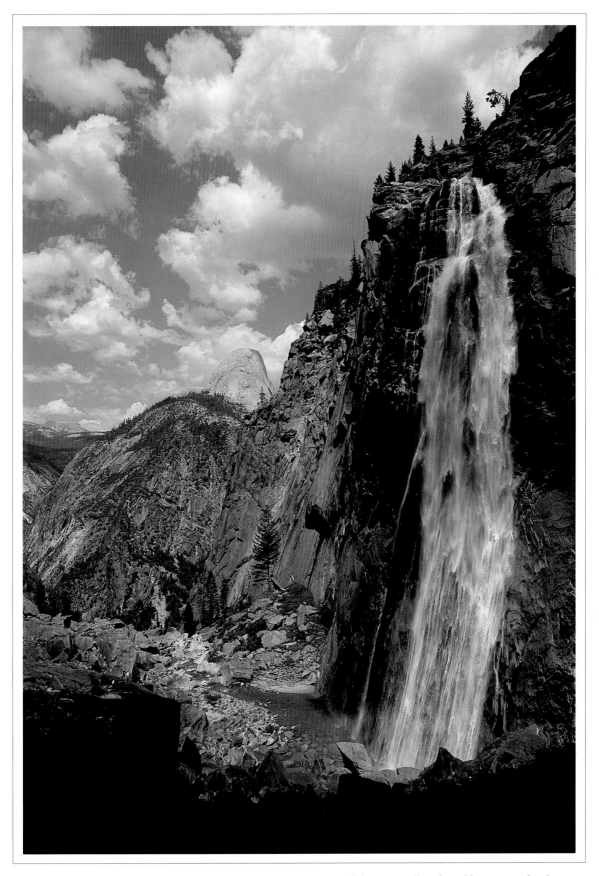

Illilouette Fall with Half Dome in the distance

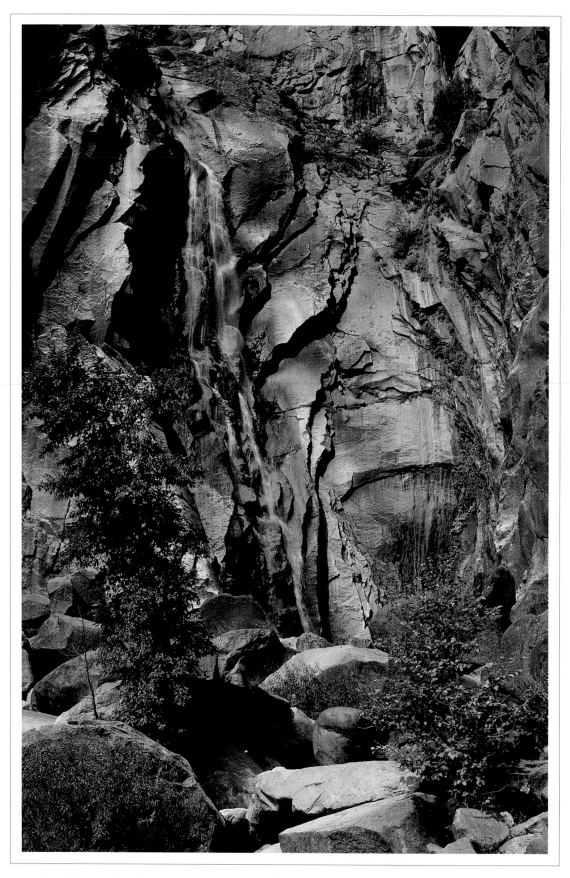

Jointed and fractured rock in amphitheater of the Cascades

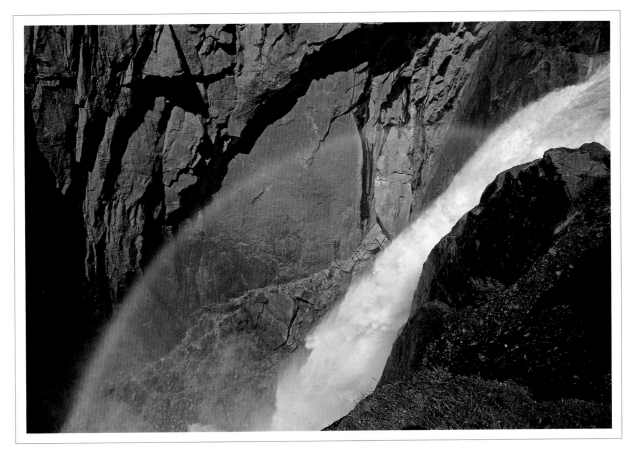

Amphitheater at Lower Yosemite Fall

cascades into free-leaping waterfalls at the mouths of hanging valleys. After each advance, the glaciers retreated, leaving meltwater to form a deep lake in the eastern end of the Valley.

Glaciations from later periods, which did not fill the Valley proper, did little to further alter its appearance. The ice was deeper in Tenaya Canyon, however, and continued to pluck and quarry the rock there, eventually smoothing the walls into the shape they retain today.

While great mountain-building forces are responsible for the topographic grandeur of Yosemite Valley, it is weathering and erosion that have carved and sculpted the finishing touches to those majestic features that draw our attention—the waterfalls. The process is analogous to a sculptor revealing the hidden potential in a block of marble by progressively chipping away at the material and then shaping the remainder to liberate the work of art formerly hidden within.

Weathering is the slow disintegration of rock under the influence of a chemically reactive mixture of water, atmospheric gases, and products of organic decay (i.e., vegetation). The weathered rock, once reduced to gravel or sand, is easily transported by the aforementioned agents of erosion. While water and ice have always been the primary long-term erosive agents at work in Yosemite, wind and earthquakes also play a part.

Erosion of granitic bedrock can only be understood in relation to the role of joints in the evolution of the landscape. Joints are straight cracks usually found as sets of parallel fractures in the rock. In Yosemite's terrain, joints are of overwhelming importance because

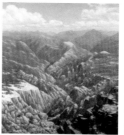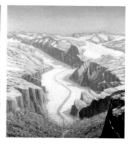

From left: Broad Valley Stage, Mountain Valley Stage, Mountain Canyon Stage, Early Glacial Stage, Last Glacial Stage. Courtesy Yosemite National Park Museum.

they form zones of weakness in otherwise massive, erosion-resistant rock. Joints provide avenues of access for water and air, both of which promote weathering, even if the rock itself is underground. Unfractured granite, on the other hand, is impermeable and weathers extremely slowly.

Significant cracks that have allowed deep weathering and erosion are called "master joints" and are responsible for the development of many of the familiar sights in Yosemite Valley. A vertical orientation of a set of master joints is responsible for the sheer face of Half Dome as well as the cliff giving Upper Yosemite Fall its free-leaping form. Parallel angled joints delineate the repeating western faces of the Three Brothers and the series of ledges below Glacier Point forming the tread of Staircase Falls. In addition, master joints frequently control the orientation of stream and river channels; from aerial photos it can be easily seen that the course of Yosemite Creek above the falls follows these master joints. The location and flow of the Merced River and the orientation of the Valley itself were also fixed by the existence of these major joint systems.

The joints that weakened the rock enabled glaciers to carve away and remove huge amounts of granite, and thus transform Yosemite Valley's steep-sloped canyon walls into the sheer-fronted cliffs we see today. They are also responsible for the "hanging valley" type of waterfall found throughout the Valley. Located where the various tributaries are bisected by the Valley's walls, these falls were cut by the sides of the glaciers grinding across creeks that

ran perpendicular to the flow of the glacier (and later of the river).

In addition to creating these hanging valley falls, glacial carving also produced cascades or waterfalls on stair-like steps in canyon bottoms called "glacial stairways." The streams descend their canyons over successive rock steps, and at each step is a cascade or waterfall where the stream plunges to the next lower tread. Many steps have sloping faces over which the stream glides in an angled cascade; other steps are vertical, or nearly so, and these form impressive, free-leaping waterfalls.

A step occurs at the point where a glacier (and later a stream) has broken through an area of highly jointed, fractured rock just downstream from an area of solid, unbroken rock. The glacier plucks and quarries the broken rock, leaving the massive rock upstream standing as the riser of a step on the stairway. The area where the broken rock has been removed becomes the level tread of the stairway. These glacial stairways and their attendant cascades or waterfalls exist along the main stems of all the rivers in the Sierra, and smaller versions occur on their tributaries. Perhaps the best example of a glacial staircase in Yosemite is the stepped sequence of falls on the Tuolumne River starting just above Glen Aulin.

Another result of glacial activity on today's waterfalls was the construction of moraines. As glaciers advance, the piles of rock and debris they scrape up, much as a bulldozer does, are often deposited in linear ridges both along the sides of glaciers (lateral

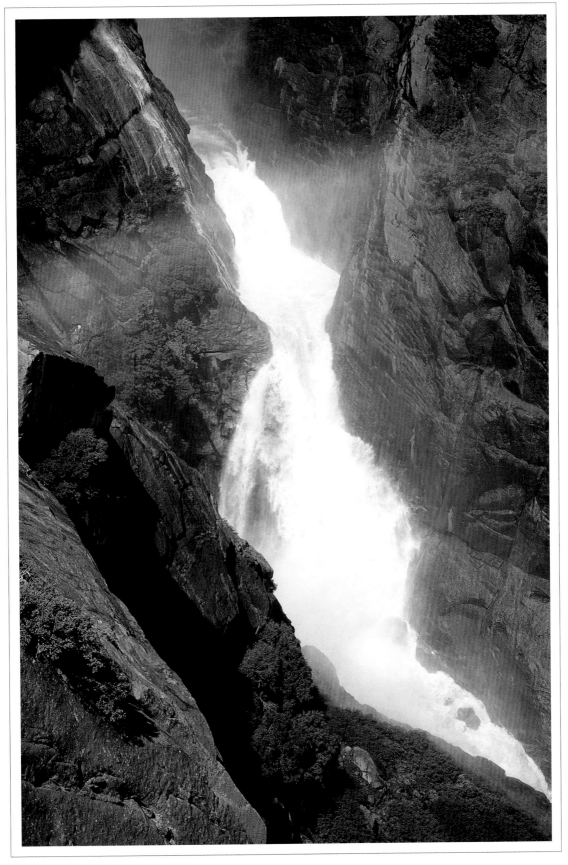

Fall at the lower end of Inner Gorge between Upper and Lower Yosemite Falls

moraines) as well as across the streambeds at the front of glaciers as they retreat (terminal moraines). Like terminal moraines, lateral moraines also can be deposited across stream channels, although these block tributary streams rather than the main one. The stream usually cuts right through the obstructing moraine and continues on its merry way; however, sometimes a moraine diverts the stream from its original flow into a new channel. When this occurs upstream from a waterfall it can completely alter the location and appearance of that fall. Some waterfalls (including the spectacular Upper Yosemite Fall) look the way they do today because a glacial moraine altered the course of their upstream channels.

Since the end of the Ice Age, geology's influence and impact on Yosemite's waterfalls has continued, albeit at a much slower pace. The rock walls fencing the perimeter of Yosemite Valley have been subjected to continuous weathering and erosion at the hands of climate and gravity, but pitted against hard granites, this dismantling has been slow enough that many of the cliffs still retain their glacial profiles. In places where cliffs are lined and fractured by large and small joint systems, erosion has been much more efficient, and the bases of these cliffs are littered with cone-shaped piles of rock and debris called talus. In some places the talus piles are more than four hundred feet high.

One of the primary agents of this weathering is the process called "frost wedging," which occurs most effectively in areas where the rock is extensively laced with vertical fractures. During the colder months, water seeping into these cracks freezes and, when it expands, loosens and dislodges successive blocks of rock. Where fracture zones occur near waterfalls, the freezing spray of the fall hastens the disintegration of the rock to create a diverse group of recesses and alcoves framing the waterfall. The towering amphitheater at Ribbon Fall is the most outstanding example of this selective frost wedging; the recesses at Lower Yosemite and Illilouette are also spectacular.

The amount of talus at the base of a waterfall indicates how much it may have changed since glacial times. A fall over a massive cliff with little rock waste at its base, such as Upper Yosemite Fall, has probably changed very little; a fall over broken or highly jointed rock with a large accumulation of talus at its base, such as at Sentinel Falls, has probably been altered significantly by post-glacial weathering.

These are the many components of the geological "recipe" in the formation of Yosemite Valley's incredible waterfalls: uplift, stream erosion, glaciers, joints, and continual weathering and erosion. Each has played a part in the fabulous creations we behold today.

THE WATER

Now that we have seen how millions of years of geology have worked to prepare Yosemite's fabled cliffs for waterfalls, it is time to discover where the water that gives them life comes from. Since the Sierra Nevada receives little to no precipitation between May and November, the main source of Yosemite's water is the snow that accumulates on the high peaks and valleys of the Yosemite Wilderness during winter storms. The uneven precipitation throughout the year is reflected in the waterfalls' seasonal variations and changing flows: they typically start slowly in the early spring, crank up to gangbuster volume by the start of summer, and then slowly dissipate until by fall they are either barely trickling or bone dry. During fall and winter storms the falls are reborn but usually at a low volume, at which they continue with minor fluctuations until the next spring runoff begins.

To understand the flow volume of a waterfall, you must understand watersheds. The terms "watershed" and "drainage" are used interchangeably to refer to the entire area from which precipitation is collected and funneled in runoff. Various features of a watershed (e.g., size, location, soil depth) determine the amount of water that a waterfall receives. Rain and snow are the lifeblood of the wilderness, affecting every square inch of land and nurturing each living plant and animal

Detail of the cliff behind Illilouette Fall

within the watershed. Gravity collects this water and pulls it ever downhill, along the way gathering it into rivulets, then creeks and rivers, and perhaps to the brink of a waterfall, where it provides a dazzling display for the amusement and delight of humankind.

The amount of snow that falls in a watershed is the primary factor determining the volume of a waterfall, and there are two components involved in how much snow falls in the watershed: size and average elevation. Size is easily understood—the larger the area, the more snow falls on it. The impressive Vernal and Nevada Falls on the Merced River have a watershed of about 118 square miles. Major waterfalls on the Valley's tributary streams have watersheds from 62 to 4 square miles, while the smaller falls are fed by watersheds from 4 to 1

square mile. Drainages small enough to be measured in acres are referred to as catch basins.

The average elevation of a watershed also affects the amount of snow that it receives. As incoming Pacific storms are pushed higher and higher up the western slope of the Sierra, most of the moisture is squeezed out as snow at elevations between about 6,000 and 8,000 feet. Below 6,000 feet, most of the precipitation is rain, and above 8,000 feet, among the highest peaks and plateaus, the air has lost much of its moisture and so less snow falls there than at the middle elevations. Even at high elevations, however, a large enough watershed can supply a significant volume of runoff, as is the case with the Sierra crest in Yosemite, which is large enough to feed the upper Merced River watershed and provide a spectacular springtime show for

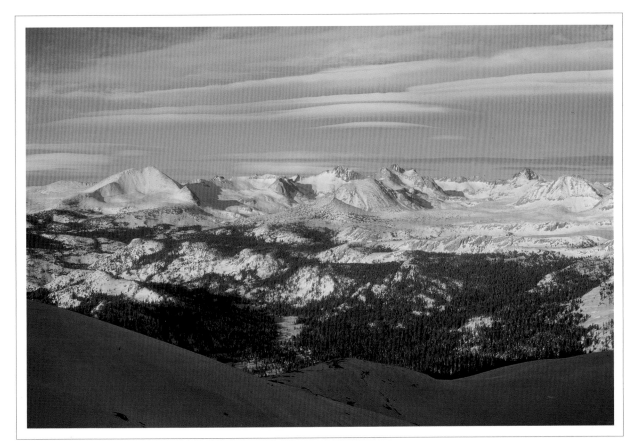

High country snow, source of Yosemite's waterfalls. Photo by Stephen Botti.

Nevada and Vernal Falls and other cascades on the Merced above the Valley.

Another factor to consider in evaluating the flow of a waterfall is the depth of the soils in its watershed. Deeper soils retain more moisture, which is released slowly over the season, prolonging stream flow in the area. The amount of soil in a given watershed depends upon how often and to what extent the drainage was glaciated; drainages repeatedly scoured by deep glaciers were scraped down to bedrock and have had only since the end of the Ice Age to renew their soils, whereas unglaciated watersheds have had vast periods of geologic time to develop deep soil cover. It is for this reason that Yosemite Falls dries up in autumn while Bridalveil Fall does not, even though the latter's watershed is only half the size of the drainage that feeds the former.

The spring runoff usually starts slowly in April, picking up in volume as the days become longer and warmer. Lower-elevation and south-facing watersheds begin the runoff first. These drainages get warmer temperatures and earlier, longer, and more direct sunlight—all factors that increase snowmelt. The average peak flow for all the waterfalls usually comes in May or early June, after which the flow decreases gradually during the dry summer until, usually by the end of July, most of the snow from the higher elevations has melted and the surface runoff is gone. Thereafter, stream flow becomes dependent upon water stored in, and slowly released from, the soil.

During August and September, much of the soil moisture becomes depleted and, one by one, many of the tributary falls disappear. Only watersheds with sufficiently deep soils can support their

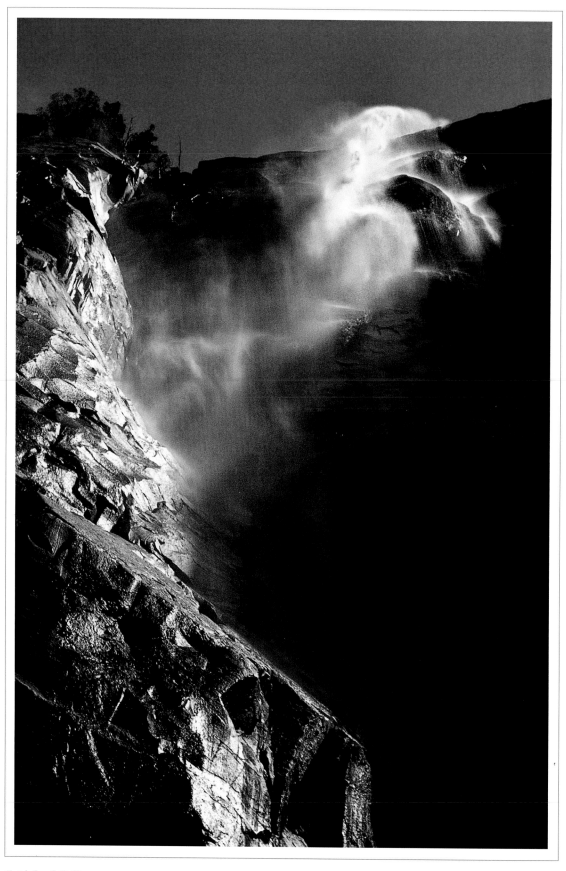

Bridalveil Fall

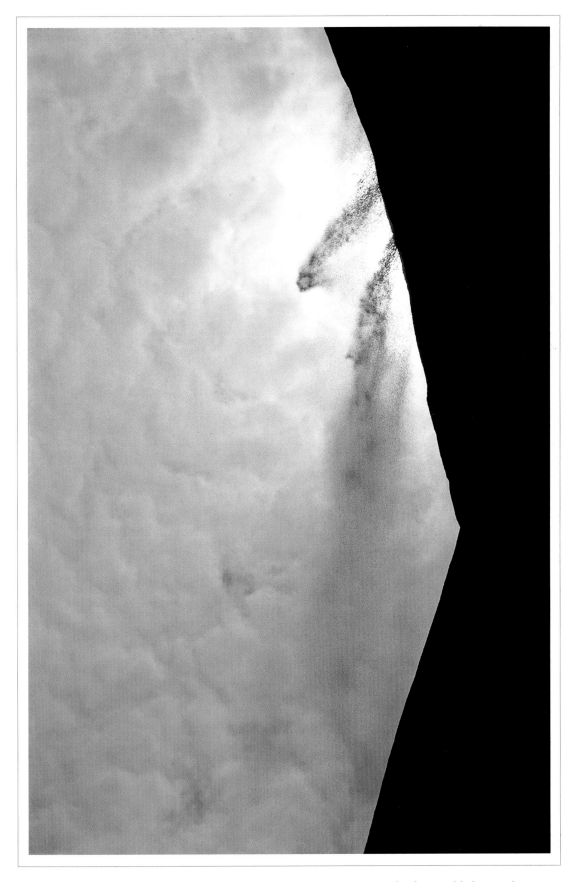

Unnamed ephemeral below Basket Dome

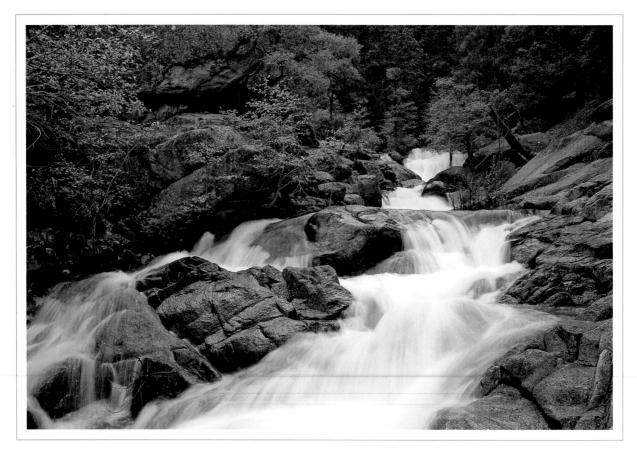

Tamarack Creek above the Cascades

waterfalls into the fall. Rainstorms in late autumn replenish soil moisture and runoff and the falls return, although much subdued from their spring-time grandeur. During the short days of winter, warm and sunny periods between storms keep the falls alive. And with each storm, more snow is stockpiled in the mountains above for the following spring's runoff, beginning the cycle anew.

In addition to the seasonal ebb and flow, there are daily fluctuations in the waterfalls' volume depending upon how long each day's snowmelt takes to reach the rim of the Valley. Although each fall has its own individual pattern, the daily volume is greatest after sunset and least in the early morning hours after sunrise. As summer advances and the snowline retreats from the waterfall to higher (and cooler) elevations, the time required

for that day's meltwater to reach the fall is likewise increased. There are also differential daily flows based on the location of the watershed relative to the sun. South-facing drainages get more sunlight and the day's melt starts sooner than on north-facing slopes. Of course, during periods of high water these daily variations are hardly noticeable in the waterfalls themselves, although the cumulative effect of all of the waterfalls usually can be discerned in the volume of the river. The level of the river is noticeably higher at night than it is in the morning. By midsummer, as the overall water flow begins to decline, the differences in volume are even more detectable to the observant visitor, who can often see the differences in the falls' water volumes at sunrise and sunset.

Yosemite waterfalls are infrequently subjected to

sudden and dramatic alterations by thunderstorms. An exceptionally intense summer thunderstorm, especially in a rocky drainage such as Yosemite Creek, which has little soil to retain the water, can greatly expand the volume of a fall within the space of a few minutes. Likewise, because of the localized nature of the thunderstorm, a swollen fall will begin shrinking as soon as the crest of the runoff passes the top of the fall; by the following day it is almost back to normal. Royal Arch Cascade and Horsetail Fall are both particularly susceptible to thunderstorm impact because of their rocky catch basins. A thunderstorm over a watershed like Bridalveil Creek, which has deep soil coverage, also boosts the water supplied to the fall, but the effect is much less dramatic because the soil itself retains much of the rainfall.

Even more dramatic than the impact of a summer thunderstorm are rare warm winter rainstorms that occur after a snowpack has already been established in the high country. Warm rain and above-freezing temperatures can cause the snow to melt and mix with the rainwater, thereby swelling the wintertime dribble into a torrent far surpassing the spring runoff. The water rushes "simultaneously from a thousand slopes in wildest extravagance, heaping and swelling flood over flood, and plunging into the Valley in stupendous avalanches [of water]," wrote John Muir of a "flood bloom" in the winter of 1871. Standing near the head of the Valley in the midst of the storm, he described the scene as "probably the most glorious

assemblage of waterfalls ever displayed from any one standpoint." There were about five of these wintertime flood events in the twentieth century, culminating with the incredible flood of 1997. While winter floods certainly create an impressive waterfall display, they are hazardous and destructive events. The Valley now contains much more infrastructure than in Muir's day, and floods are hard on roads, bridges, utilities, and accommodations.

Finally, while considering the relationship between weather and waterfalls, we must acknowledge that Yosemite is not immune from the effects of global climate change. The fact is that Yosemite Valley is much warmer in the winter than it used to be. The average snowline is now higher than it was in Muir's time; in his day, many storms brought snow to 4,000' (the elevation of the Valley), and temperatures in the Valley were cold enough that early residents and visitors frequently

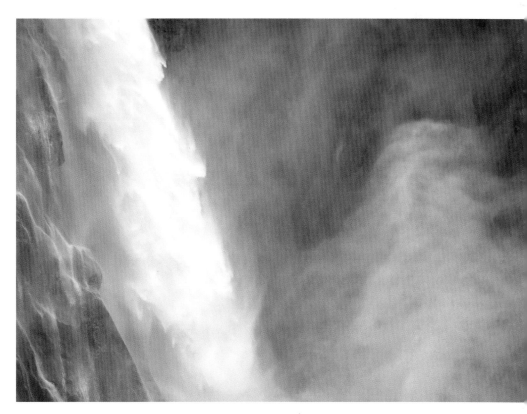

The Cascades and mist. Photo by Michael Frye.

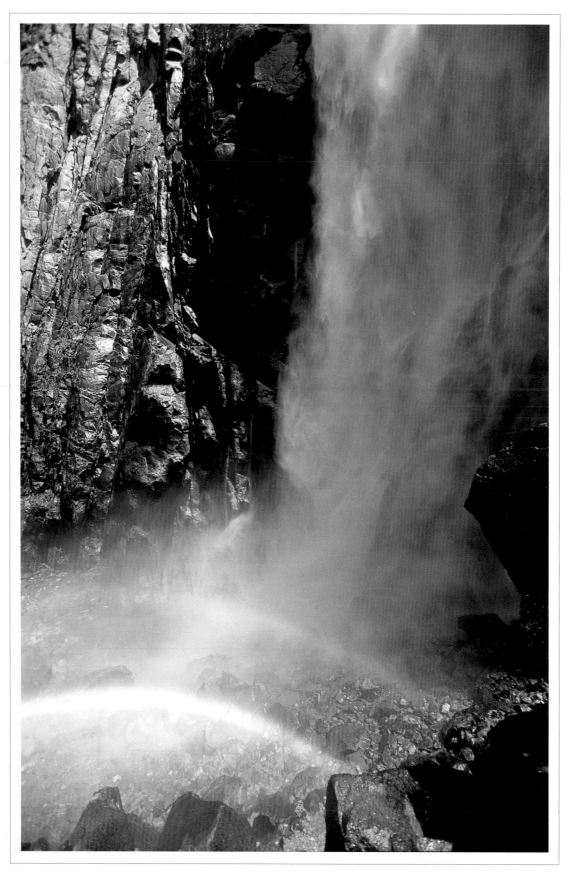

Rainbows at the base of Bridalveil Fall

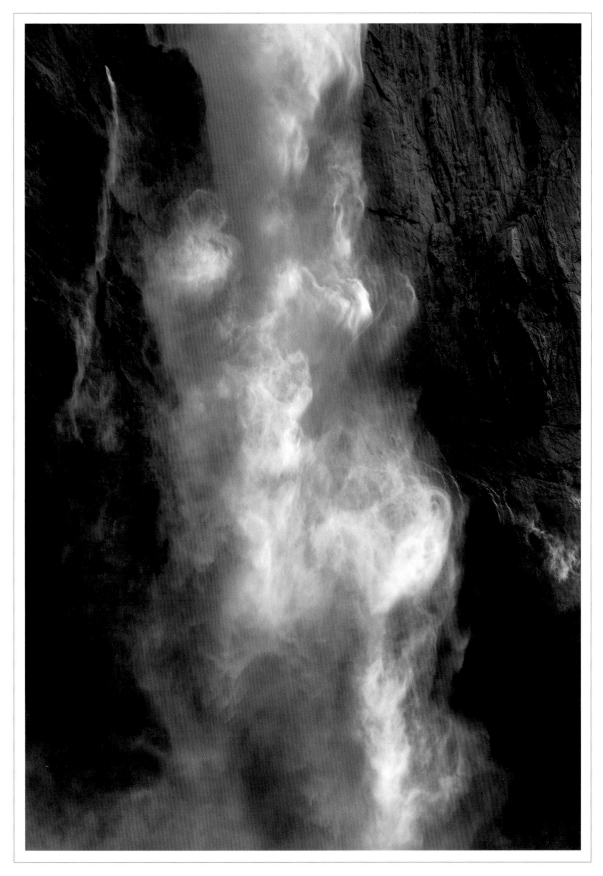

Upper Yosemite Fall. Photo by Charles Cramer.

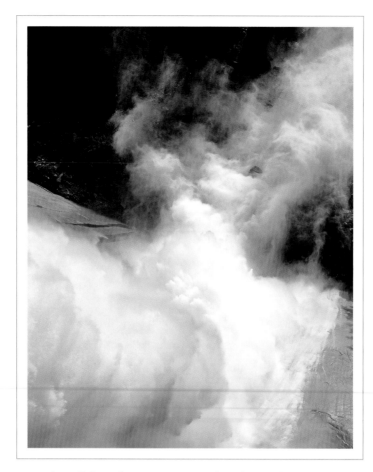

Nevada Fall from the top at sunset. Photo by Keith Walklet.

ice-skated on the Merced River. Higher snowlines mean that a greater percentage of the water that goes over the waterfalls comes from rain instead of snow, and elevations that previously remained snowbound all winter are now experiencing melting during warmer periods between storms. Both of these issues alter the timing of flow and mean that the waterfalls now have greater volume during the autumn and winter than they did in the past. But higher snowlines and more wintertime snowmelt also reduce the amount of water stored in the watersheds and thus tend to decrease runoff in the spring and the length of time the falls flow in the summer. The winter floods in Yosemite Valley seem to correlate to El Niño events, but it remains to be seen if global warming will increase their frequency and impact. In any event, the seasonal cycles of the waterfalls have definitely been altered, both in volume and timing, by the same climate changes evident all over the world.

Visitors to Yosemite Valley are presented with a never-ending variety of experiences regarding the waterfalls. People who arrive in late summer and early autumn are sometimes underwhelmed and express disappointment that they "missed" the falls. But isn't the variety better than being faced with something that never changes? As the falls shrink in volume, they become more subject to buffeting by the wind and their aerial and ethereal beauty can compensate for what they lose in power and majesty. And even bone dry, they tease the imagination with anticipation of the miracle to come.

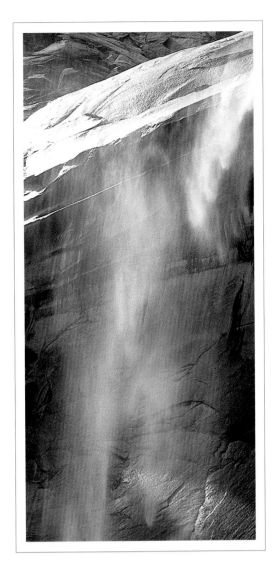

THE EPHEMERALS

In his book *Discovery of the Yosemite*, Lafayette Bunnell tells us that the Indians had given names to the numerous smaller falls that pour into the Valley during the season of melting; unfortunately, he did not attempt to record or interpret the native names of these falls because "they are but mere suggestions of the grander objects that overshadow them." John Muir, among other early writers of Yosemite's glories, invariably observed that, after glowing descriptions of the "major" waterfalls, "the others are seldom noticed or mentioned, although in almost any other country they would be visited and described as wonders." To Muir, all falls could be equally "beautiful and interesting, if we only had a mind to see them so." Therefore, the more inconspicuous waterfalls are presented first in these pages, with the intent of fostering their appreciation.

The smallest of waterfalls are called ephemerals (meaning "transitory" or "short-lived"). With drainage areas of less than one square mile, and frequently *much* less, these falls are of short duration and small volume, but nevertheless worthy of our attention. They grace the Valley's walls for the first few weeks of warm weather and then pass from the scene. They are mostly unnoticed, unmeasured, and unmentioned in the literature on Yosemite's waterfalls. And unsurprisingly, most are also unnamed.

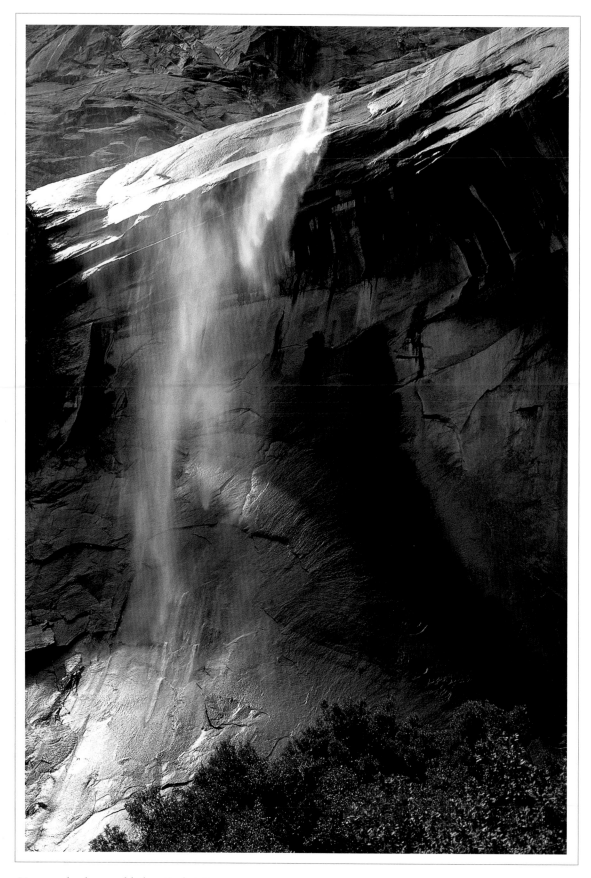

Unnamed ephemeral below Basket Dome

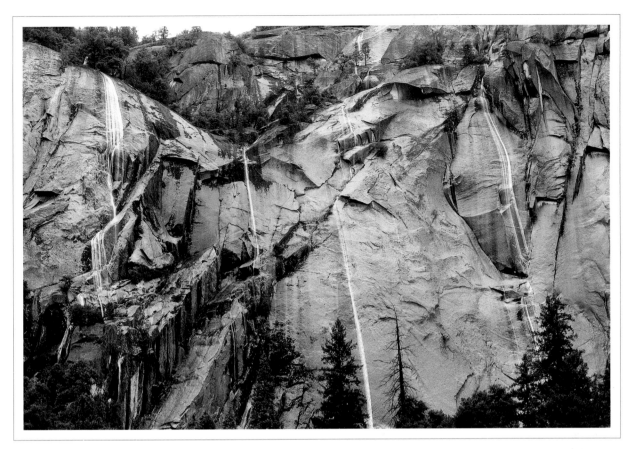

Unnamed "pour-off" ephemerals during a thunderstorm

One of the prettiest, and among the author's favorites, hangs over an exfoliated, bowl-shaped depression in the west wall of Tenaya Canyon just beneath Basket Dome. It draws its water from the gully formed by a major joint that also shapes and controls the abrupt north face of that dome. Cascading down this gully and over the edge of the bowl, the stream suddenly becomes free-leaping for the next several hundred feet. In addition to its incredibly beautiful setting, the small volume of the stream permits the canyon winds to tease the fall into charming swirls and blowing tatters. This waterfall can be seen from several locations on the Loop Trail around Mirror Lake, but be sure to take binoculars with you because it is high on the wall and close views are not possible. This unnamed fall can also be seen from Glacier Point but at that distance is almost imperceptible.

Another ephemeral of particular beauty is found in a huge amphitheater high on the southern rim of the Valley just east of Silver Strand Fall. Probably a thousand feet high, it is not free-leaping but glides down the cliff in a slow and stately procession, bumping and splashing over numerous small ledges on its way down. In addition to its aesthetic appeal, this fall is of geologic interest for its prominent recess; carved primarily by frost wedging, this recess is nearly as large as the one created by Ribbon Fall, even though the volume of its stream is but a fraction of Ribbon Creek's. The controlling variables are the highly jointed rock and the cold, frost-friendly location rather than water volume or the cutting power of the stream. In winter this north-facing fall never sees the sun and in that perpetual shade, the water freezes solid

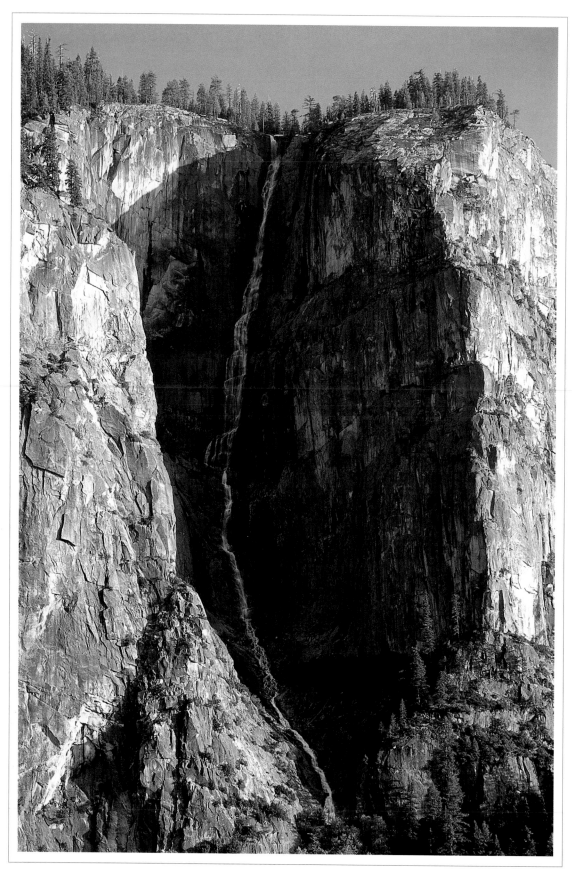

Widow's Tears

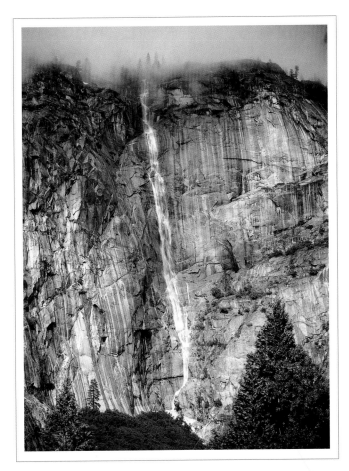

Unnamed ephemeral above Camp 4

to become an ice cascade, giving it a more substantial appearance in winter than it has as a flowing waterfall during the light spring runoff. Although this waterfall would earn its own state park status anywhere else, it remained almost totally unknown to generations of visitors until it was discovered in 1975 by enthusiasts of the extreme sport called ice climbing. Ice climbers call this officially nameless fall the "Widow's Tears," which was a name previously applied to Silver Strand Fall, located just to the west of this impressive amphitheater and ephemeral. Hidden high above and within its nook, the Widow's Tears is only visible from near the Merced River just downstream from Pohono Bridge. Its height and relative obscurity surely qualify it for preeminence among the unknown waterfalls in the Valley and makes worthwhile the effort required to find it.

A third ephemeral, one which alternately leaps and slides as it descends, begins near Washburn Point on Glacier Point Road, although it cannot be seen from there. Located on the west wall of Illilouette Gorge about halfway between Glacier Point and Illilouette Fall, it usually flows for about a month in late spring or early summer. The interesting part about this site is not the little fall itself so much as the incredibly varied and complex structure of the cliff over which it flows. There is no way to get anywhere near this ephemeral, and without binoculars it basically fades into the immensity of its surroundings. I included it here because it can easily be seen from some locations on the Mist and Panorama Trails, and I'd like to encourage people to at least look for it.

Another fine example of Yosemite's transitory

prominent during warm, sunny periods in late winter or early spring, and by the time summer arrives it is already gone. While it lasts, however, this fall is quite engaging and easily visible from many locations near the Lodge and Chapel and, more closely, from some switchbacks on the Upper Yosemite Fall Trail.

Of the Valley's many ephemerals, only two have been officially named. The first, about a thousand feet high, is El Capitan Fall. This dainty driblet, as if in counterpoint to the massive bulk over which it leaps, adds subtlety to the bold lines of El Capitan. The waterfall is perhaps too subtle, though, for it frequently goes unappreciated in the presence of El Cap's immensity. The thin column of water, which slides over the top near the east buttress, is often caught in the turbulent air currents around the cliff and blown into the likeness of a streaming tail. When gazing up at the eastern half of El Cap, it is not too difficult to imagine a powerful galloping horse with the waterfall appropriately located where the tail would be: thus the name "Horsetail Fall," by which it is almost universally known.

One of the most appealing aspects of Horsetail Fall requires the low angle of winter sunlight. If there has been sufficient snowfall, and if there is a period of warm weather in February, the snow melts to give us a special wintertime apparition: at sunset the fall may be bathed in a fiery golden glow against the background darkness of the rock wall. The water truly appears to be on fire. Whole generations of photographers too young to have ever seen the original, but artificial, "Firefall" of burning embers off Glacier Point now call this the firefall. Most people consider Horsetail Fall's show to be the far superior spectacle of the two.

The south-facing catch basin for this fall drains the melting snow from the steep, rocky, and sloping eastern half of the mountain's crown. Because of its small catch basin and susceptibility to warm spells in the winter, this fall exhibits great variability in both when and how well it flows. It can be

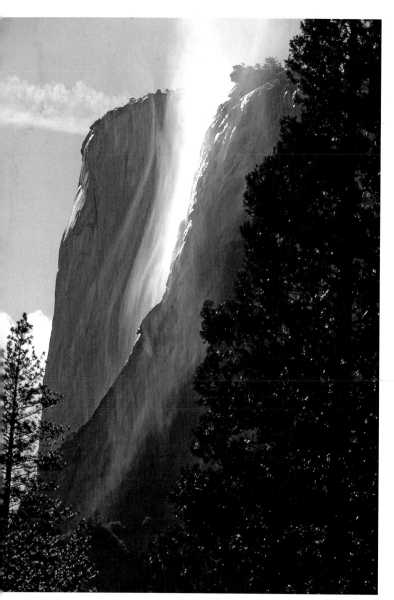

Horsetail Fall during afternoon up-canyon winds

waterfalls is the one that glides down the nearly perpendicular cliff above Camp 4. It is of exceptionally short duration because its catch basin faces south and so receives the full warmth of the sun, which quickly melts its meager supply of snow. But the trade-off for the fast-melting snow is that the water volume for the fall is larger than if its supply were hoarded all season and doled out more slowly, as happens on the north-facing (or south) side of the Valley. This fall is especially

36

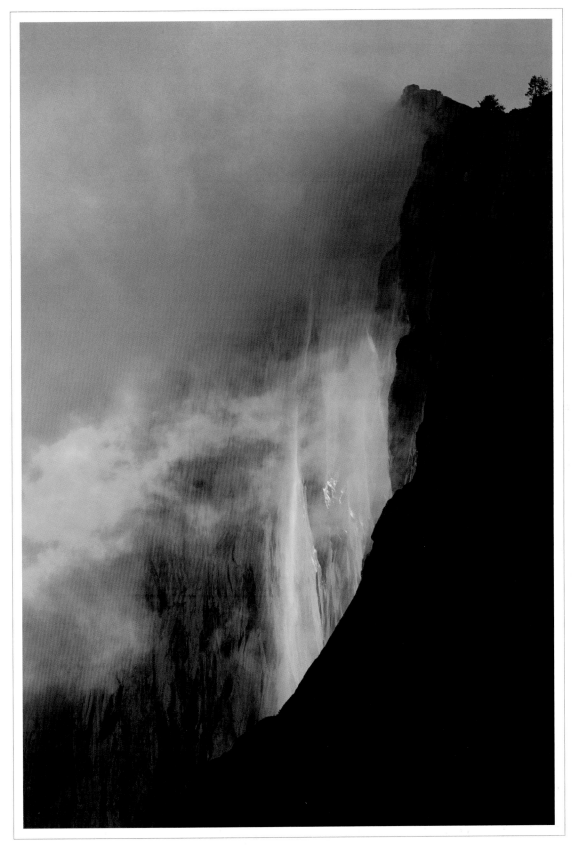

Horsetail Fall, clearing storm. Photo by Jeff Grandy.

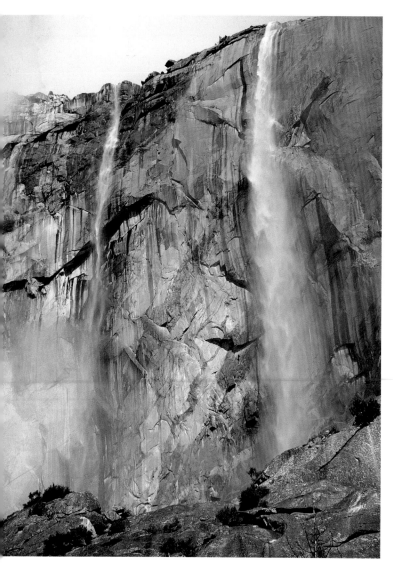

Horsetail Fall (on right) and an unnamed ephemeral on El Capitan

fond of calling these two "Ponytail" and "Pigtail," but fortunately they remain officially unnamed. Their locations are marked by dark lichen streaks near the top of the cliff, and this is all most people ever see because the extreme conditions required to generate them are rare.

Aside from Horsetail, the other named ephemeral, aptly called Staircase Falls, clearly demonstrates that the form of a waterfall results from the structure of the underlying rock. On the cliff face below Glacier Point there is a prominent system of parallel, sloping ledges—the outward expression of a series of oblique master joints within the rock. The course of the falling water is directed along these glacier-carved ledges eastward in a series of step-like falls producing a staircase effect. Consequently, the base of the fall is more than 1,000 feet to the east of its top, and the total drop is only 1,300 feet.

Just west of Staircase Falls is a massive vertical joint that cleaves the cliff face from top to bottom, producing a deep gully in the cliff and a small basin on the rim above. The Glacier Point parking lot is located in this basin at the head of the gully, known as LeConte Gully because it strikes the Valley near the LeConte Memorial. Snowmelt from the basin and upper gully feeds Staircase Falls; the stream travels down the upper half of the gully but is diverted at the highest of the oblique ledges where it intersects the gully (at about the midpoint of the cliff). An inspection of the intersection of ledge and gully has revealed that there is a talus buildup where the two meet. This is interesting because it is entirely feasible that LeConte Gully was the original course of Staircase Creek and that it was only the result of a fortuitous rockfall that the stream was diverted and thereby created the delightful waterfall we see today.

Because Staircase's catch basin is north-facing and heavily forested, it receives little direct sunlight and so the snowmelt proceeds slowly. Also contributing to the low stream flow is the fact that the basin is

either spectacular or a bust depending on various factors. Horsetail is at its best if early winter snows have piled up high enough to provide sufficient meltwater to sustain the flow. It generally dribbles for most of the winter and is only really active during warmer periods. Usually the fall is dry by early spring. Even after all the snow has melted, however, a summer thunderstorm above El Cap may regenerate the fall. A heavy rain may even foster the appearance of two even smaller ephemerals spilling over the top of the cliff to the west of Horsetail. A former tour guide in the park was

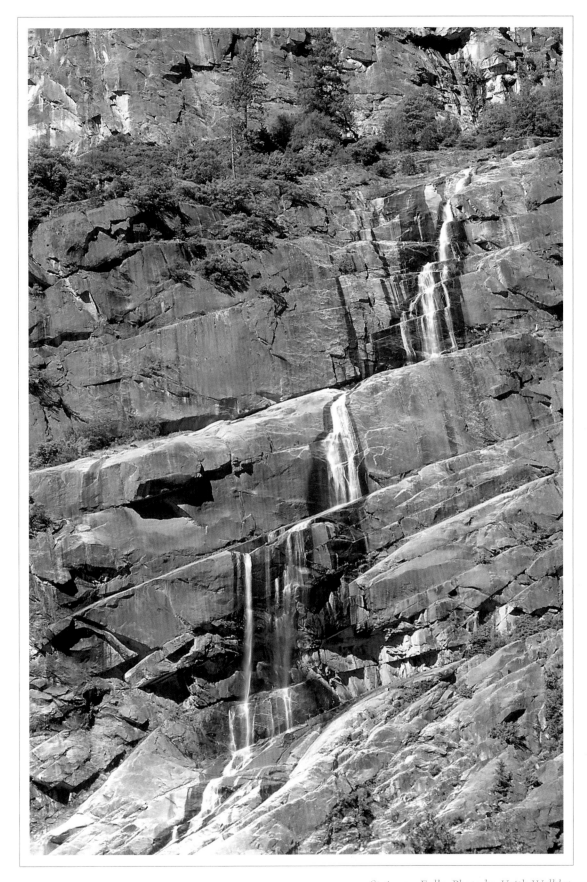

Staircase Falls. Photo by Keith Walklet.

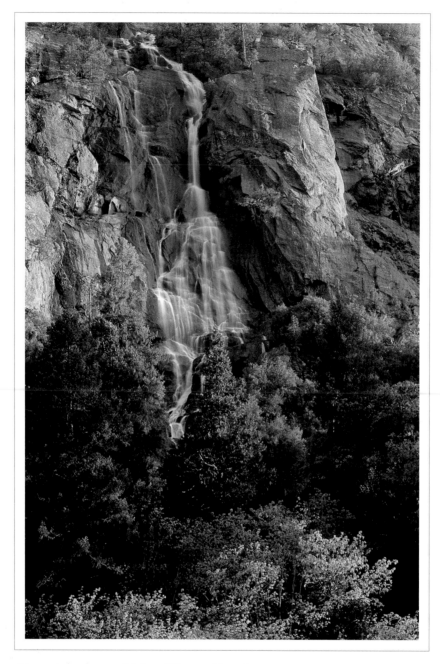

Unnamed ephemeral below Wawona Tunnel

high enough that it was never glaciated and therefore has deep soil coverage. The soil retains water and releases it slowly, maintaining a low volume to the waterfall for a short time after the snow runoff has finished. The falls can be viewed from many spots in the eastern end of the Valley, but two of the best are Housekeeping Bridge and Church Bowl.

Not all of the Valley's ephemerals are pictured or even described here. There are many others, each with its own grace and beauty. Readers are invited to search for these elusive waterfalls and to choose their own favorites.

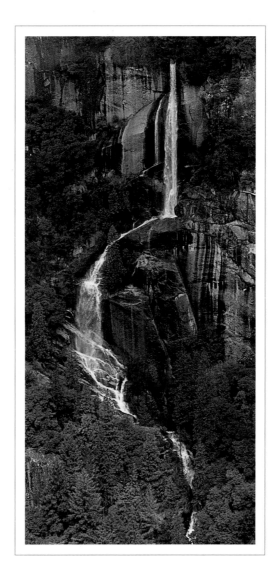

THE MINOR WATERFALLS

The least of Yosemite Valley's waterfalls are often known by the charming and euphonious designation of "ephemeral." The grandest and most magnificent of the falls can be described by a host of elite superlatives. But searching for what to call the ones in the middle has proven difficult. Are these waterfalls "pretty good," "not so bad," "average," "intermediate"? The difficulty is that, although these falls are surely less spectacular than some of their brethren, they are no less wonderful or amazing and deserving of admiration. I settled on calling them the "minors," no denigration implied.

Avalanche and Grouse Creek Cascades

West of the Valley itself, both above and below the Arch Rock entrance station and across the river from the El Portal Road, course two of Yosemite's least appreciated cascades. The first encountered on a trip up to the Valley is on Avalanche Creek, which reaches the river just below Arch Rock. The second one, just above the entrance station, is on Grouse Creek. The main point of interest for these two waterfalls lies in how different they look from the falls in the Valley above them. Valley falls tend

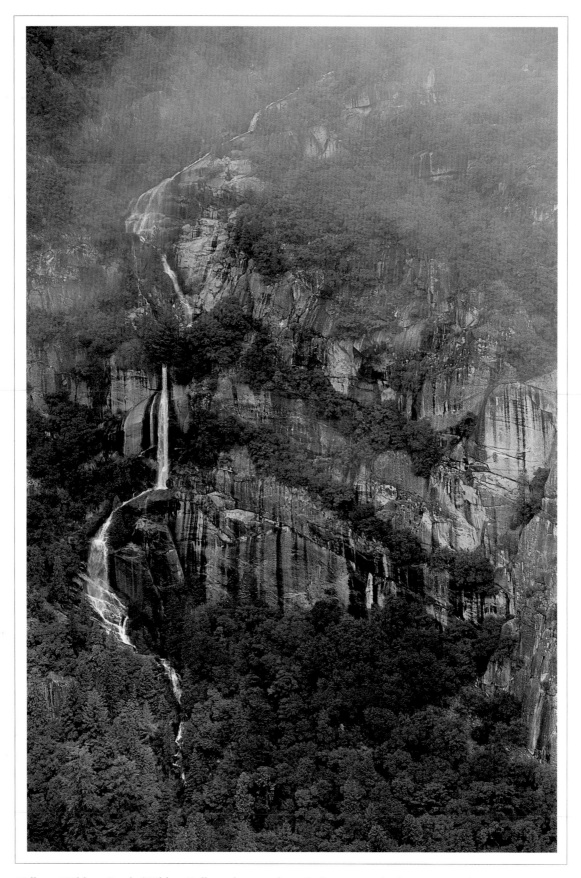

Falls on Wildcat Creek (Wildcat Fall can be seen through the trees in the lower portion)

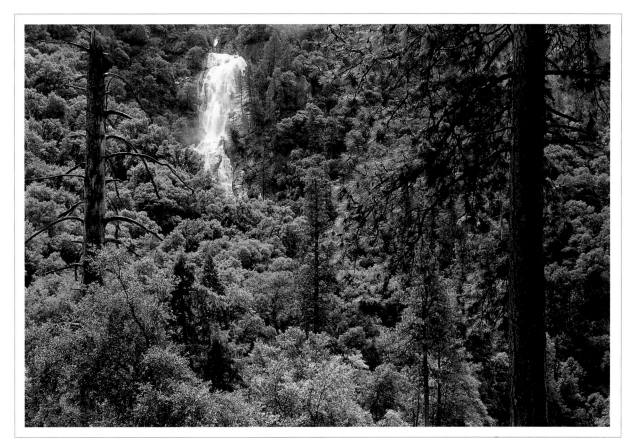

Grouse Creek Falls, near Arch Rock

to leap, or at least glide, over bare rock expanses, whereas Avalanche and Grouse are largely confined to steep, tree-covered, rock-choked channels. The reason behind the terrain is that this area is so far down from the source of the glaciers that the ice made it this far only during the earliest period of the Ice Age. Therefore, the canyon received only minimal widening and so retained much of its original V-shaped appearance. It is interesting to consider that most of Yosemite's waterfalls must have looked very similar to these before glaciers chopped away their lower sections and left their watersheds hanging above smooth, vertical cliffs.

One segment of the Grouse Creek Cascade abandons its rock-filled channel to tumble down a broken, rocky cliff face. This approximately two-hundred-foot section acts like an actual waterfall

instead of continuing the cascade-like behavior of the rest of the creek. When Francois Matthes was doing his fieldwork studying the glacial history of the Valley, he discovered the remnants of a lateral moraine high on the canyon wall above the cascade. This moraine diverted the creek from its previous channel into a new one, the result of which was this waterfall. The old channel is still visible about a half-mile upstream from the "new" waterfall.

The headwater of the Grouse Creek watershed terminates at the Badger Pass ski area and is the larger of the two drainages. Neither of the watersheds above the canyon rim was glaciated and so both have deep soils and are heavily forested. Runoff is best during warm weather in winter and in spring. Avalanche Cascade, in particular, is hardly noticeable except at near maximum flows because

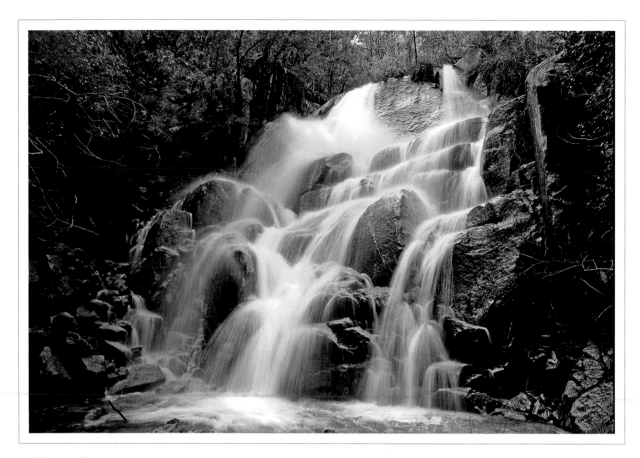

Wildcat Fall

it is mostly confined to a narrow channel and obscured by trees and shrubs. Both are also underappreciated because the El Portal Road corridor is so narrow and winding that there are no turnouts near these cascades where one can safely stop to admire them. Neither cascade was ever named except in being referred to by its respective creek.

Wildcat Fall

About two miles farther up the canyon from Grouse Creek, on the north side of the river and about a quarter of a mile downriver from the Cascades, is the captivating fall on Wildcat Creek. The creek tumbles about seven hundred feet in a cascade chain down the canyon wall on the north side of the river. Like the previous two cascades, Wildcat

Fall is not easily seen by visitors. Although alongside the road, it is often overlooked because trees obscure the lower section from view. In fact, if it were not for a short section of the cascade a couple of hundred feet above the trees—visible in places on the El Portal Road—few people would even know this waterfall exists. Portions of this cascade are also visible from the big turnout above the tunnel on the Wawona Road. The lower section, even though seldom seen and of small volume, is also quite pretty, especially in spring when framed by the fresh green of new foliage. It seems to be this lower portion that earned Wildcat its designation as a "fall" as opposed to a "cascade" because the entire chain clearly has the character of a cascade.

In contrast to all the tumultuous drama—the crashing, boiling, and spraying that accompany

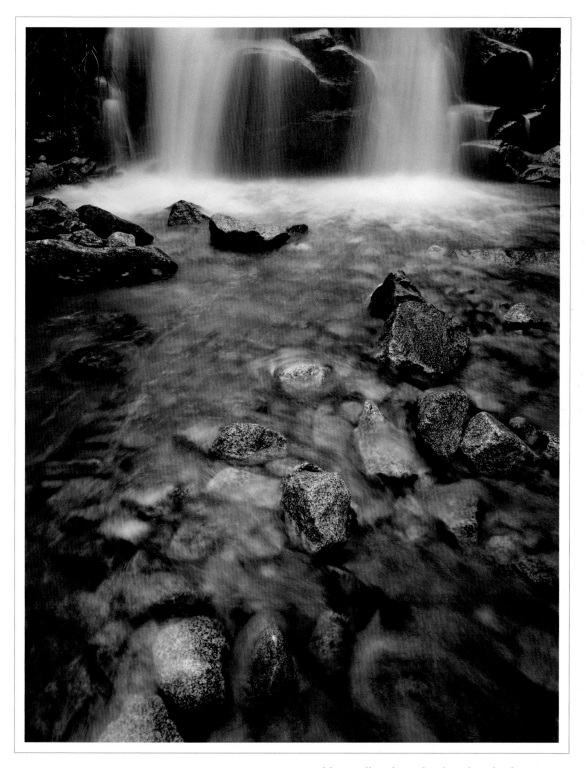

Wildcat Fall and Creek. Photo by Charles Cramer.

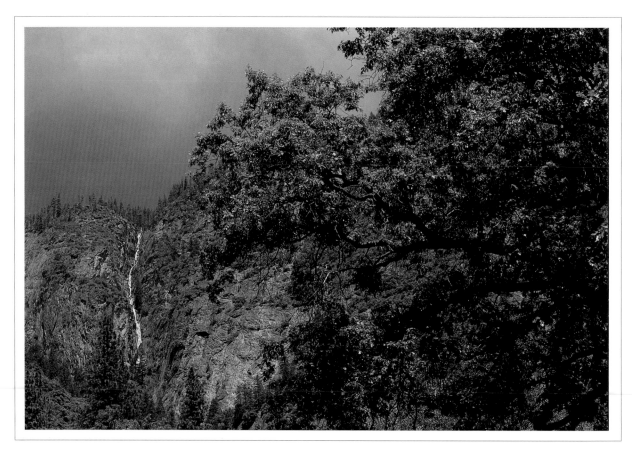

Lehamite Falls, from Cook's Meadow

most of Yosemite's waterfalls—the water at the base of Wildcat possesses a delicate beauty, flowing like silk from rock to rock. With a watershed of only about one square mile, its flow is usually down to a slow trickle by early summer.

Lehamite Falls

Although in a conspicuous location, Lehamite Falls, high on the east wall of Indian Canyon above Yosemite Village, is another of the lesser known among the Valley's minor waterfalls. The upper two-thirds of the falls consists of a cascade chain confined to a narrow gorge in the east wall of Indian Canyon. In the bottom third, the stream spills out of its gully and flows over a cliff. This waterfall can easily be seen from the Yosemite Village and Cook's Meadow areas, although few people seem to notice it; this is another fall that requires binoculars to fully enjoy.

Lehamite Creek is essentially the smaller eastern fork of Indian Creek, which lies hidden among the rocks and trees at the bottom of Indian Canyon. In spite of its small volume, Indian Creek has been able to trench its valley down to the level of the Merced River, matching only Tenaya and Illilouette Creeks, the two largest tributaries of the Merced in the Valley. The creek was greatly aided in its erosive work in Indian Canyon by the yielding nature of the highly jointed rock over which it flows. The slightly smaller Lehamite Creek, however, flows through more durable granite, which, except for the gully trenched by the cascade above the fall, has been fairly resistant to erosion. As the west fork trenched deeper, the valley

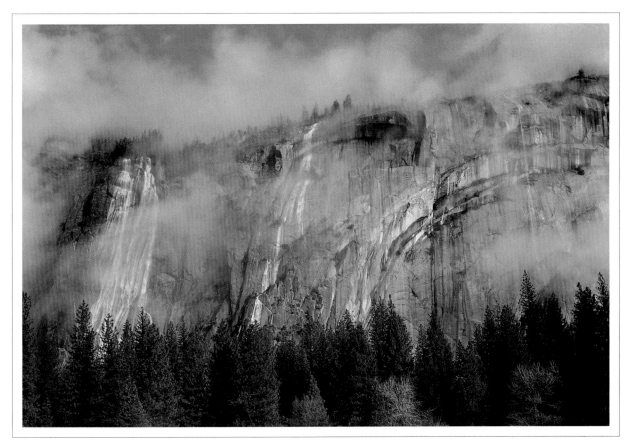

Royal Arch Cascade (on left) and unnamed ephemeral, clearing storm

of Lehamite Creek was left hanging just above the confluence of the two forks, creating Lehamite Falls. The Lehamite Creek watershed was never glaciated and so has sufficient soil coverage to keep the falls flowing well into the summer, but the flow itself is so paltry that, at such height above the Valley, the fall really is best appreciated through binoculars.

According to Lafayette Bunnell, the Native Americans living in the area knew Indian Canyon as "Le-ham-i-te," which he understood to mean "arrow wood." The Mariposa Battalion adopted the name Indian Canyon, as it provided a path used by the Indians to access the high country and the trans-Sierra trade route to the Mono Basin. Over time, the name Lehamite came to be associated with this obscure cascade, although what the Indians actually called it is unknown. Among the early books on Yosemite,

the main reference made to it is in Hutchings's *In the Heart of the Sierras*; he called it "Little Winkle" and that name appears on several early maps.

Royal Arch Cascade

Royal Arch Cascade, characterized by Hutchings as "a diamond-lighted, wavy, musical rivulet," is Lehamite's neighbor to the east. With a total descent of about 1,250 feet, the cascade glides down the Royal Arches wall in a series of parallel, shining ribbons. The south-facing catch basin of Royal Arch Creek is less than a square mile and has very little soil, meaning water retention is minimal and spring runoff is correspondingly rapid. By midsummer only the dark streaking of lichen is left on the cliff where water had flowed.

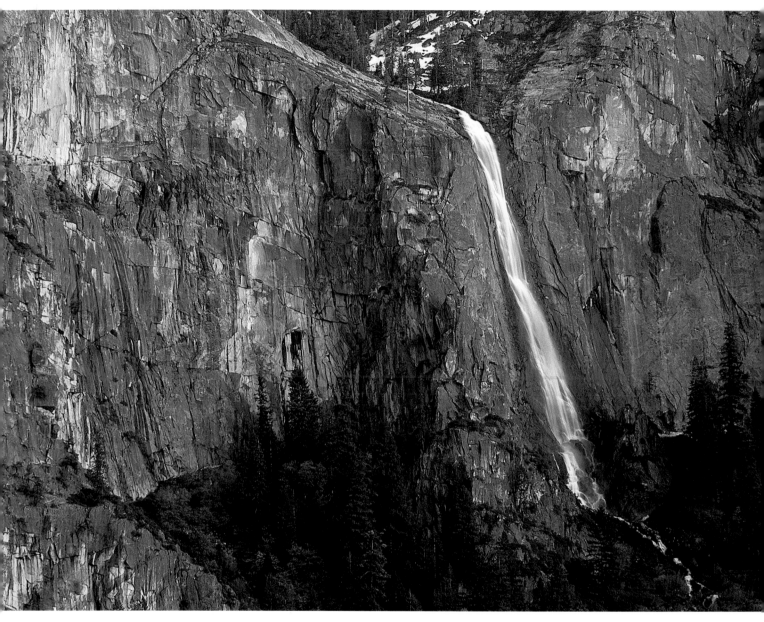

Silver Strand Fall

This fall presents its most dramatic appearance during heavy rainstorms, when the collected runoff transforms it into what Muir called "a broad ornamental sheet." The steep southern face of North Dome and the precipitous rocky expanse below it funnel the runoff into a wide and impressive display. The best places to watch this waterfall are from Ahwahnee and Stoneman Meadows. The trail from the Ahwahnee Hotel to Mirror Lake passes right under the fall and offers guests a wonderful opportunity to appreciate the water-generated music floating on the breezes. Each step along the trail subtly alters the notes of the symphony.

The Royal Arches were named by one of the soldiers of the Mariposa Battalion; the gigantic exfoliated arches reminded him of symbolism associated with the Masonic Lodge. (The Royal Arch Mason is the highest degree in the Freemasonry order.) Bunnell tells us that the Indians called this fall "Sho-ko-ya, the Basket Fall" because it drained the area adjacent to "To-ko-ya, the Basket." We now call this upside-down basket-shaped rock "North Dome," while the name "Basket Dome" has been given to the clearly non-basket-shaped dome behind it to the north.

Silver Strand Fall

Another cascade of the slender ribbon type is Silver Strand Fall. Located in an angular recess in the southern wall above Tunnel View, it drops 1,170 feet into the talus at the base of the cliff. Silver Strand Fall is fed by a small stream known as Meadow Brook—oddly the only creek in Yosemite designated as a "brook"; it may have been named by East Coast visitors reminded of a small stream back home. Because of its small watershed, Silver Strand is of low volume and is usually dry by midsummer. However, during warm springs following heavy snow years, the runoff is sufficient that for a few weeks the waterfall is spectacular. It is especially lovely in the late afternoon light before the sun slips behind the ridgeline to the west.

It is surprising that Silver Strand is not better known considering its visibility from Tunnel View. Perhaps it's that the view into the Valley is so compelling that many never notice the waterfall high above them. Neither Muir nor Bunnell includes it in his description of the Valley's falls, and Josiah Whitney, in his *Yosemite Guide-Book*, mentions it briefly but not by name. One visitor said in 1878 that her guide called it "Inspiration Fall," but this name was never in common use. Maps and accounts published about the Valley until the 1920s called it "The Widow's Tears," the joke being that it flows for such a short period. This attempt at humor so outraged a later visitor that he wrote in 1911, "Is it too much to hope that a dignified Department of the National Service will refuse to perpetuate this sickly designation, and in future maps employ the natural title of Meadow Brook Fall?" The name Widow's Tears was not continued, but neither was it changed to Meadow Brook Fall. Francois Matthes apparently proposed the name Silver Strand, and that name has been in use since around 1927. Meanwhile, wintertime ice climbers have appropriated its former name for the frozen ephemeral located around the corner of the south wall to the east of Silver Strand.

Sentinel Falls

Sentinel Falls, the long cascade in the recess west of Sentinel Rock, drops about two thousand feet over successive rock steps. Controlled by intersecting master joints forming chevron-shaped structures in the rock, these steps produce an interesting chain of falls of various heights. Most are from fifty to two hundred feet high, but the chain is terminated by a massive leap of five hundred feet to the talus below. In volume and height it joins Royal Arch Cascade as being the most impressive and well known of Yosemite's smaller waterfalls. The never-glaciated hanging valley of Sentinel Creek is the highest in the Yosemite region, opening 3,340 feet above the Valley

floor. Its headwater is located in the vicinity of Pothole Meadows near the Glacier Point Road. Although this slightly larger watershed tends to keep Sentinel Falls flowing longer than Silver Strand Fall and Royal Arch, it too is usually dry by midsummer.

Seldom noticed is the unnamed ephemeral cascade in the gully just west of Sentinel Creek. Like Sentinel Falls, it takes the form of a long chain of falls because the intersecting oblique and vertical joint systems within the rock—the same kind that occur at Sentinel—are repeated here. Having a small catch basin on the rim of the Valley rather than an actual watershed, it has little volume and

soon disappears. While it lasts, however, it forms a charming replica of its larger neighbor. Both are easily visible from Leidig Meadow and Northside Drive to the west of the Lodge.

The knife-edge ridge between Sentinel and its duplicate ephemeral, at a point just above the terminal leap of both falls, consists of highly fractured rock that has been crumbling away from both sides. The visible scar of rockfall from the zone of weakness can be clearly seen in both drainages, and the fresh talus at the base of each fall is readily apparent. This rockfall demonstrates that the processes that created Yosemite's waterfalls are still in action.

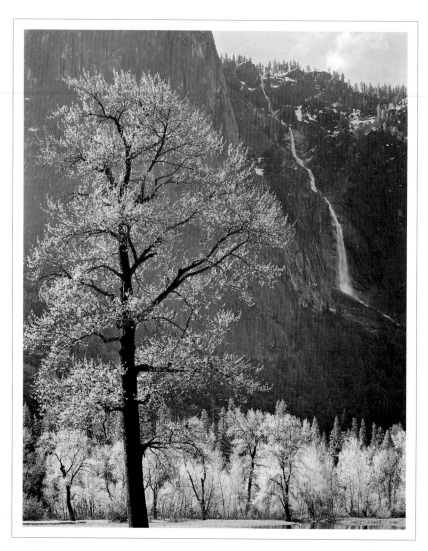

Sentinel Falls from Leidig Meadow. Photo by Annette Botaro-Walklet.

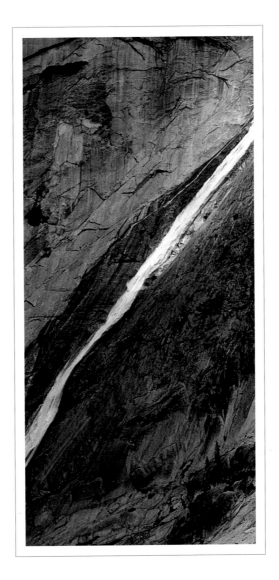

THE FALLS OF
TENAYA CANYON

When viewed from Glacier Point, the great depth of Tenaya Canyon is its most striking feature. Both stream and glacier have cut with relative ease into a narrow belt of highly fractured rock to create the canyon's surprising proportions. Its width has been less affected because of the resistance offered by the massive rock in the canyon walls. The glacier-polished rock of the upper drainage near Tenaya Lake was in fact the source of the Indian name of the creek: "Py-we-ack—the stream of the glistening rocks." The creek, and the lake near its head, were renamed Tenaya in honor of the

last chief of the Yosemite Indians, whose people were captured on the shore of that lake. According to Lafayette Bunnell, Chief Tenaya "indicated that he thought renaming the lake and creek was no equivalent for the loss of his territory."

Pywiack Cascade

Apart from numerous ephemerals, there are five waterfalls of note in Tenaya Canyon. Four of these are located on the glacial stairway of Tenaya Creek, which descends to the Valley between Tenaya and

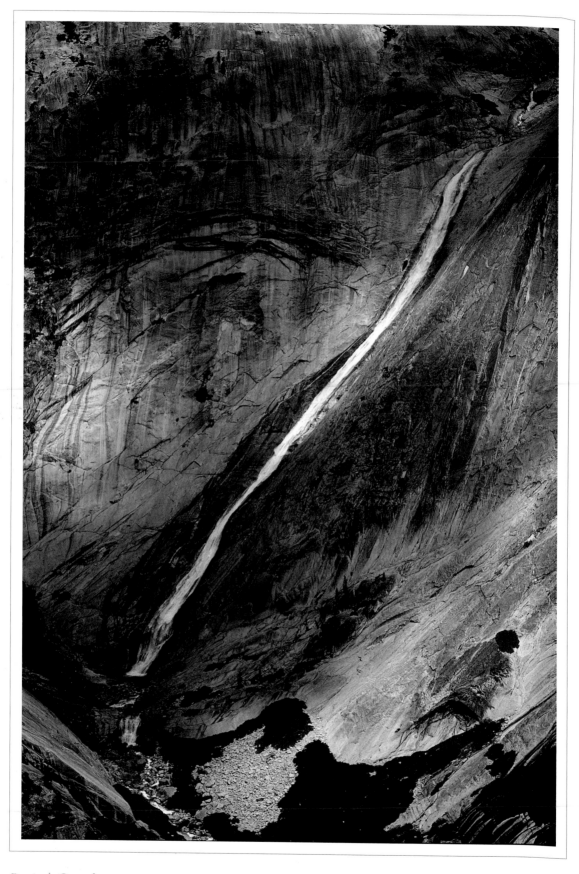

Pywiack Cascade

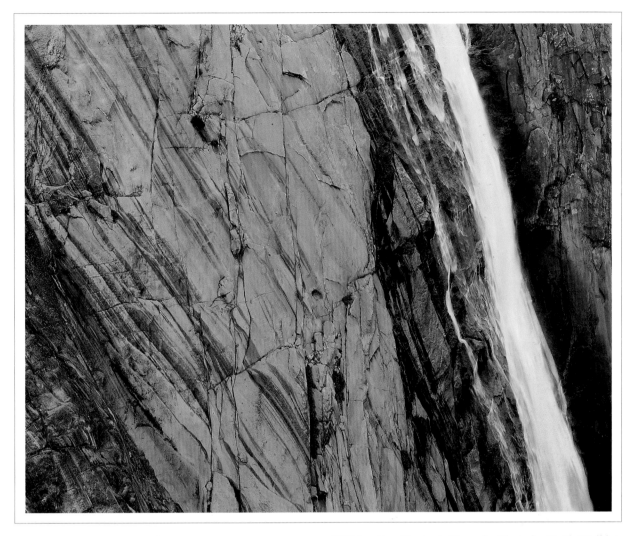

Cliff detail at Pywiack Cascade. Photo by Keith Walklet.

Mirror Lakes in a series of sloping steps rather than leaping falls. Due to the dangerous location and inaccessibility of Tenaya Canyon, none of these falls is approachable and only one is visible from a distant viewpoint. The second and by far the largest fall in this chain—best seen through binoculars from Glacier Point or the summit of Half Dome—is a cascade over a massive step of very durable rock. Over this smooth, steeply inclined, six-hundred-foot cliff glides the water of Pywiack Cascade. It is a ribbon cascade like Royal Arch, but it is also the largest and most impressive of its kind in the region surrounding the Valley. In Matthes's estimation Pywiack Cascade should be counted among Yosemite's major waterfalls.

Snow Creek Falls

As stream and ice alternately deepened Tenaya Canyon, the drainage of Snow Creek was left hanging twenty-five hundred feet above the canyon floor. It is the largest tributary stream in the Tenaya watershed and drains the southern and eastern slopes of Mt. Hoffmann and the upland west of Tenaya Canyon. The creek leaves its hanging valley via Snow Creek Falls, a booming two-thousand-foot cascade chain that joins Tenaya Creek about a mile above Mirror Lake. Because of their location within a deep, sinuous gorge, the falls cannot be seen in their entirety from any one point except the top of Half Dome, although in high water the view from

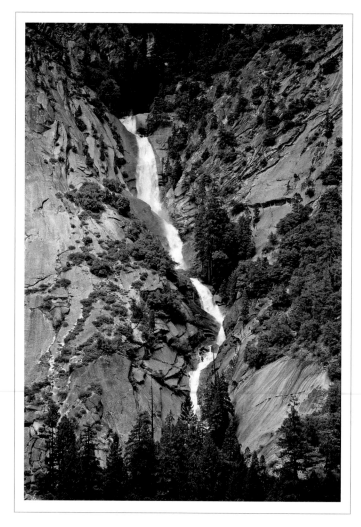

Snow Creek Falls

Glacier Point is not bad. The runoff from this south-facing watershed can be quite impressive and these falls would be much better known were they only more visible.

Looking down from the summit of Half Dome one can see the two heads of the gorge through which the fall descends to the canyon bottom. The creek formerly entered the gorge by the east head, which is now dry, but was diverted into a new channel perhaps by a moraine dam left by an early glacier. This is the same situation that we noted earlier in discussing the cascade at Grouse Creek; we will see this phenomenon again at the creek above Upper Yosemite Fall.

A good view of the lower portion of Snow Creek Falls can be obtained from the Loop Trail around Mirror Lake. Of special interest in this section is a large arched fountain of spray known as a water-wheel. Hurled out of the main body of water by an obstruction in the streambed, this is the finest example of a waterwheel near Yosemite Valley and is exceeded only by those in Waterwheel Falls on the Tuolumne River.

The Indian name for Snow Creek Falls is not known. Neither Bunnell nor Hutchings included it in their descriptions of the Valley. Muir called it "Dome Cascade" and its stream "Dome Creek," while an 1883 map labels the creek Glacier Brook. The name Snow Creek was ratified by 1896 although it was apparently in use prior to that time.

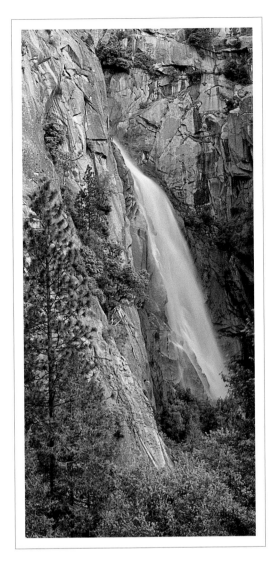

YOSEMITE'S
CROWN JEWELS

The waterfalls described thus far are known mainly to those who have the time and inclination to poke about in nooks and crannies in search of the unusual and concealed. Most of these, though glorious, are inaccessible or short-lived. Also, their obscurity derives from the fact that in height, volume, or duration they are eclipsed by their famous neighbors. In any other place, they would be marvels.

The most impressive of the waterfalls, grouped here as "Yosemite's Crown Jewels," have drawn visitors since they were first seen by James M. Hutchings's party more than one hundred and fifty years ago. When viewed against their equally grand surroundings—the cliffs, peaks, and forest-clad slopes that adorn them—they exceed our expectations and imaginations. Not surprisingly, John Muir probably said it best: "How deeply with beauty is beauty overlaid!"

The Cascades

A short distance west of the Valley proper, Tamarack and Cascade Creeks follow their individual courses down the steep north side of the Merced River Gorge. Like the cascades of Avalanche and Grouse Creeks, these sharply plunging creeks provide interesting displays of how all the Merced's

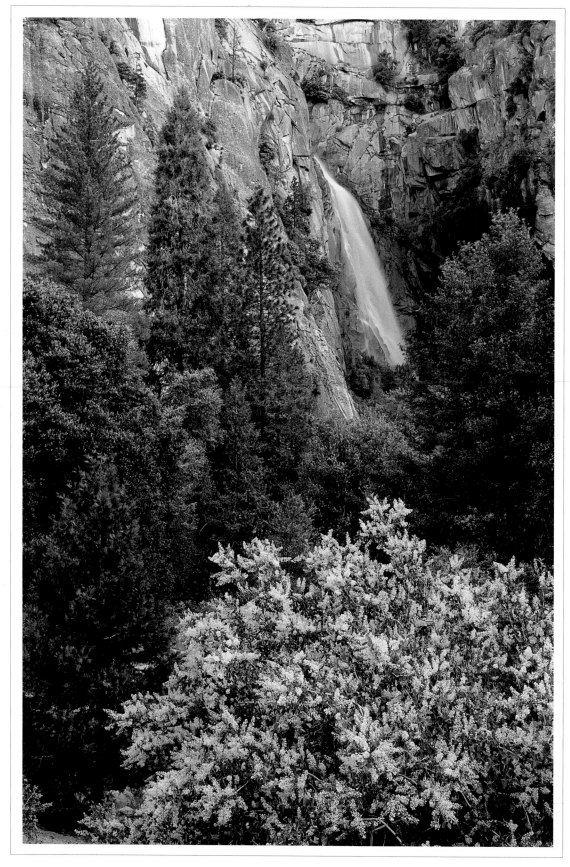

The Cascades

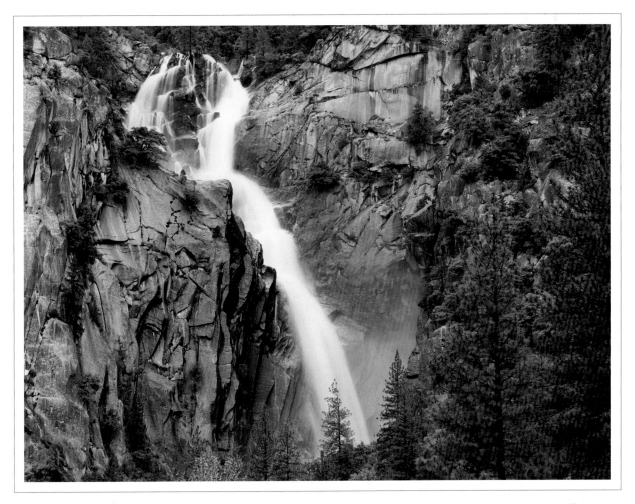

The Cascades. Photo by Jeff Grandy.

cascading tributaries must have looked before glaciers began their work on the scene. In a twisting gully about five hundred feet above the river, and just above the terminal leap, the two creeks join together to form the Cascades. To visitors following the Merced River into Yosemite Valley, this impressively churning cataract, tucked away in an alcove of the canyon wall, provides the first hint of the magnificence awaiting them farther up the Valley.

The recess into which the Cascades pour is typical of the notches and amphitheaters associated with many of Yosemite's waterfalls. The water and spray from the fall has etched the recess into a fracture zone primarily by the action of frost wedging. Notice the extent of the joint lines and shattered rock within

the alcove. Broken in descent by irregularities in its bed, the stream is pounded into mist and whisked about by the turbulent air currents within the alcove. Enchanted by this dynamic beauty, Hutchings wrote of the Cascades: "These are seen bounding over and adown the mighty crags, driving out eddies of sunlighted spray, that weave and toss their vapory veils upon the rocks and trees with such graceful abandon that the eye never wearies in watching their aerial frolics."

Interestingly, the Cascades was better known in the 1870s than it is today. The viewpoint near the road was a regular stop on the hot and dusty stage run from Coulterville to Yosemite, and after a harrowing horse-drawn descent to the canyon floor just

57

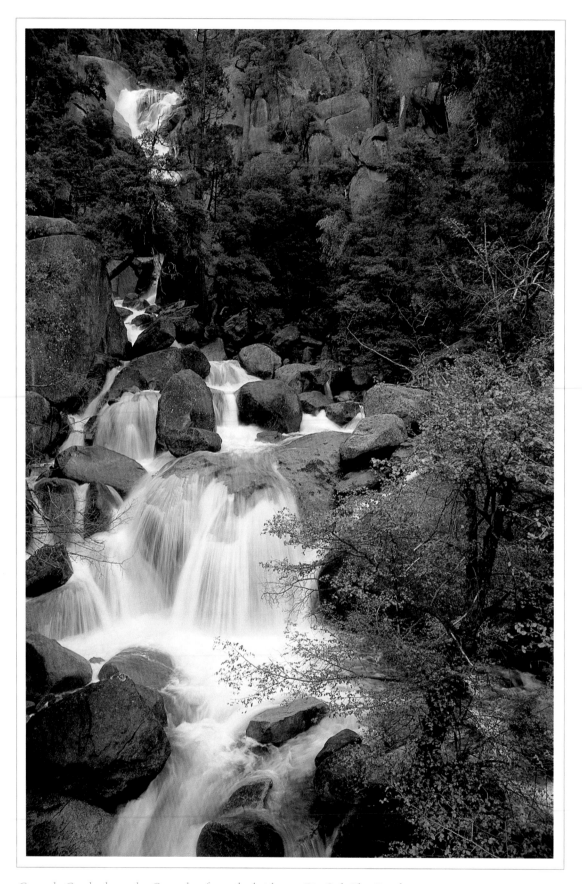

Cascade Creek above the Cascades, from the bridge on Big Oak Flat Road

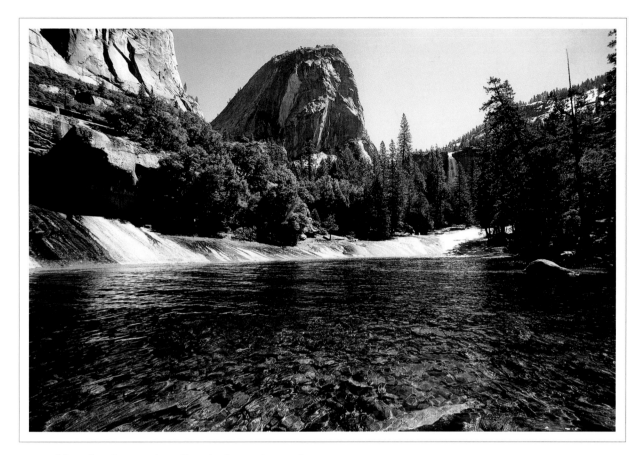

Emerald Pool with Nevada Fall and Liberty Cap in distance

west of the fall, the cool breeze and blowing mist were a welcome respite from the rigors of the road.

As a result of its ample watershed, the Cascades usually continues to flow throughout the summer. However, without replenishing rains, it usually becomes dry, or nearly so, by autumn. The best overall view of Cascade and Tamarack Creeks spilling down the canyon wall and converging in the Cascades is from the Wawona Road about a mile above the tunnel. The closest view of the Cascades itself is from the adjacent turnout on the El Portal Road. Also, a turnout on Big Oak Flat Road, where it crosses Cascade Creek, provides a spectacular viewpoint. From here it is not possible to see over the canyon wall into the alcove of the Cascades, but above the road there are impressive views of the falls in Cascade Creek. The riotous confluence of

the two creeks just before the final leap can also be seen from the bridge.

Lafayette Bunnell said that giving the plural name "the Cascades" to a single waterfall came from the "twin-like appearance" of the two cascading creeks that join into one just above the alcove. Of Cascade Creek, Muir claimed that "never was a stream more fittingly named, for so far as I have traced it…it is one continuous bouncing, dancing, white bloom of cascades."

Ribbon Fall

Ensconced within an alcove of the Valley's north rim just west of El Capitan, Ribbon Fall hangs three thousand feet above the Valley floor. With a drop of more than sixteen hundred feet, Ribbon is the

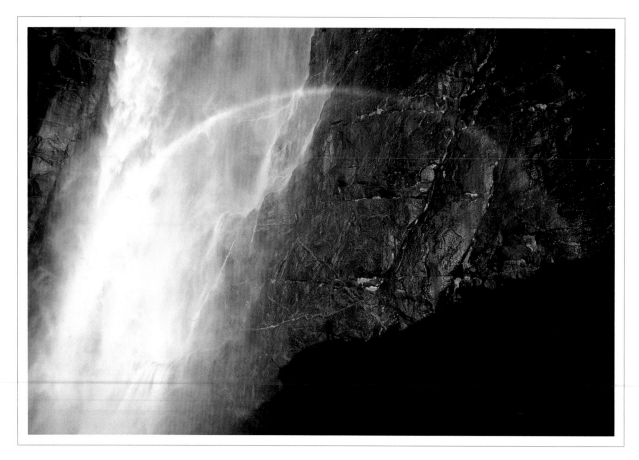

Rainbow at Bridalveil Fall

highest single waterfall in North America and is second in the world only to Angel Falls in Venezuela. That it plunges between nearly perpendicular, towering walls that frame a recess nearly one hundred yards deep makes it all the more remarkable. If it were not for the fact that so many of Yosemite's most spectacular waterfalls are easy to appreciate from close and accessible viewpoints, it would be a shame that Ribbon is so elusively distant.

Bunnell wrote that the Indian name for this fall was "Lung-yo-to-co-ya, the literal meaning of which is Pigeon Basket, probably signifying to them 'pigeon nests.'" Retaining the Indian name, Bunnell called it Pigeon Creek Fall, but this name was not adopted by those who followed. Early visitors and Valley residents knew it as "The Virgin's Tears" (a name proposed no doubt by the same wit, if not

person, who christened "The Widow's Tears" across the Valley). Hutchings gave the translation of the Indian name as "the graceful and slender one," and it was he who suggested the name Ribbon Fall, prompting Bunnell to remark that "his name is better than his interpretation." For many years both names were used, although Hutchings's choice eventually prevailed.

According to Francois Matthes, "Ribbon Creek attains sufficient volume to give its fall great splendor. Clouds of spray then shoot out from the base of the recess and swirl from the opening at the top like steam from a geyser." Muir called it a "magnificent object" and "a glorious flood" but lamented that the "suffocating blasts of spray that fill the recess... prevent a near approach."

The modest, four-square-mile watershed of

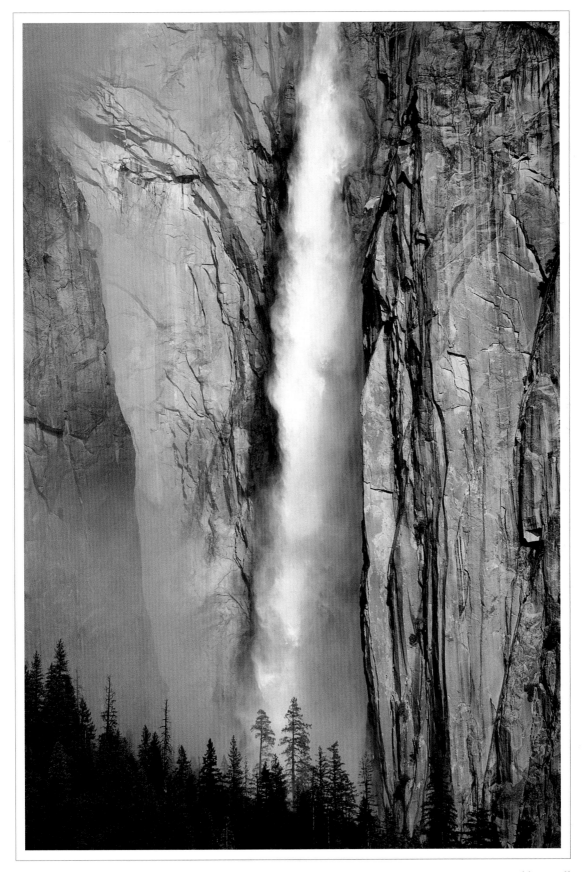

Ribbon Fall

Ribbon Creek usually is adequate to support its flow until around midsummer. Rainstorms in autumn and early winter renew the stream and the waterfall, but the flows are generally minimal, making the rejuvenated fall not nearly as impressive. One advantage of the lower autumn and wintertime flows, though, is that on cold nights the slower-moving water sometimes freezes on the cliff face, and the early morning light reveals the spectacle of sixteen hundred feet of ice clinging to the wall of the amphitheater. The view is wonderful by itself, but the prepared visitor will have binoculars through which to watch the giant sheets of ice, warmed by the rising sun, peel off and crash to the bottom. Over the course of winter a large sloping hill of ice builds up against the cliff at the base of the fall.

Wonderful views of Ribbon Fall may be obtained from many locations in the western end of the Valley; some of the best are along the Pohono Trail on the south rim and on Southside Drive near Bridalveil Fall. There are no trails to either the top or the base of the fall, so this one has to be loved from a distance.

Illilouette Fall

Near the head of the deep gorge entering Yosemite Valley just east of Glacier Point is the captivating Illilouette Fall. Called by artist Thomas Ayres "a gust of living light from Heaven," this three-hundred-seventy-foot fall is, in point of volume, the largest of Yosemite's tributary falls. John Muir, who found in each waterfall something different and appealing, wrote of Illilouette that it "is not so grand a fall as the Upper Yosemite, or so symmetrical as the Vernal, or so airily graceful and simple as the Bridalveil, nor does it ever display so tremendous an outgush of snowy magnificence as the Nevada; but in the exquisite fineness and richness of texture of its flowing folds it surpasses them all."

For many visitors the appeal of this fall is enhanced later in the season, when the volume of water has diminished. Instead of leaping clear of the cliff like Bridalveil, it glides in a thin sheet down the steep, nearly vertical cliff. Joseph LeConte, the eminent University of California geologist who visited the Valley with Muir in 1872, described Illilouette as being "woven into the most exquisite lacework, with edging fringe and pendant tassels, descending like a glorious star shower." The intricate designs and subtle colors of the cliff shine through this lacy curtain of water producing kaleidoscopic patterns of fluid motion.

Bunnell decided that the literal interpretation of the Indian name for this fall, "Too-lool-lo-we-ack" (an interpretation that has apparently been lost to time), would be inadmissible in polite company. (He actually wrote the translation in Greek—perhaps presuming that anyone able to understand Greek would not be offended by the off-color interpretation?) "But it is well enough to say," he continued, "that the word simply represented an effort of nature in the difficult passage of the water down through the rocky gorge." Originally called South Canyon Fall by Bunnell, its name was often confused as associated with the South Fork of the Merced River. This difficulty prompted Josiah Whitney to suggest that "it would be well to call the fall by its Indian name, Illilouette, one not yet much in use in the Valley." Retorted Bunnell, "The name 'Illeuette' is not Indian, and is, therefore, meaningless and absurd." To avoid confusion, "and especially because of the impropriety of translating the Indian name," he wrote, "I think it advisable to call this the Glacier Fall" because of its proximity to Glacier Point. Although history sided with Whitney on this one, the source and meaning of the name Illilouette remain unclear.

With a watershed of sixty-two square miles, the hanging valley of Illilouette Creek is the largest of any of the Merced's tributaries, draining the west side of the Clark Range and a large portion of the upland south of the Valley. The headwater of this basin is located on the divide between the main branch of

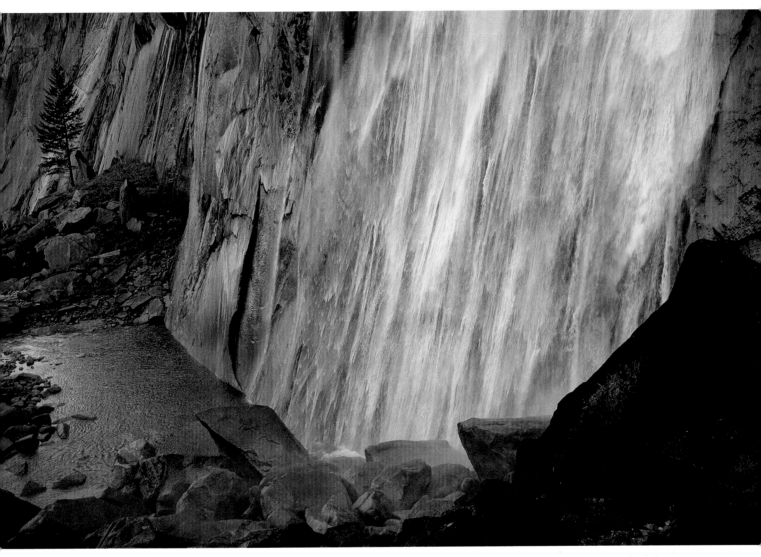

Pool at the base of Illilouette Fall

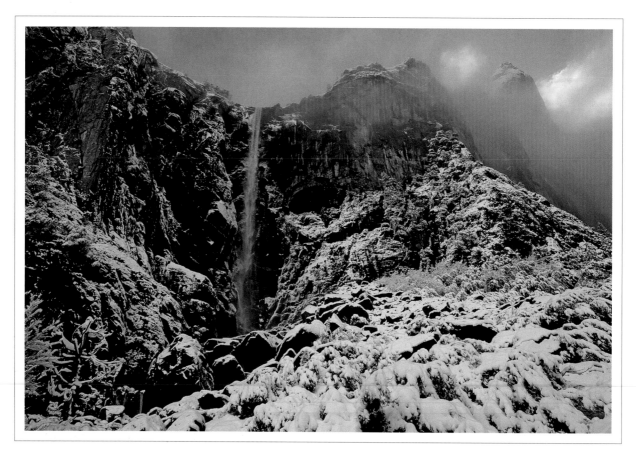

Bridalveil Fall

the Merced River and its South Fork. Here Muir found his first living glacier in Yosemite, although it has long since melted away.

The most impressive geological feature associated with Illilouette Fall is the rocky, water-choked gorge below it. This gorge, like Tenaya Canyon on the opposite side of the Valley, was cut into a zone of extensively fractured rock between two areas of massive, unjointed granite. Surprisingly, it was excavated not by the Illilouette Glacier but by the Merced Glacier. The larger trunk glacier overrode Panorama Cliff and blocked the Illilouette Glacier before it could reach the Valley. Today, through the action of frost wedging, the gorge continues to enlarge in the zone of weakness. The head of the gorge has been etched several hundred feet past the waterfall so that the fall now tumbles over the east wall of Illilouette Canyon rather

than at its head. At the still expanding end of the box canyon is a charming, spray-drenched and fern-filled alcove that Hutchings called Horseshoe Grotto. In addition to hastening the disintegration of the jointed rock, the plentiful mist from Illilouette Fall nurtures lush plant growth in the vicinity of the grotto.

In spite of its size and beauty, Illilouette is the least known and the least visited of Yosemite's major waterfalls. Although there is a distant, edge-on view of this fall from the Mist Trail below the Vernal Fall bridge, the best view is from an overlook on the Panorama Trail two miles down from Glacier Point.

Bridalveil Fall

Bridalveil's most distinctive geological feature is the superbly sculptured gulch—which projects more

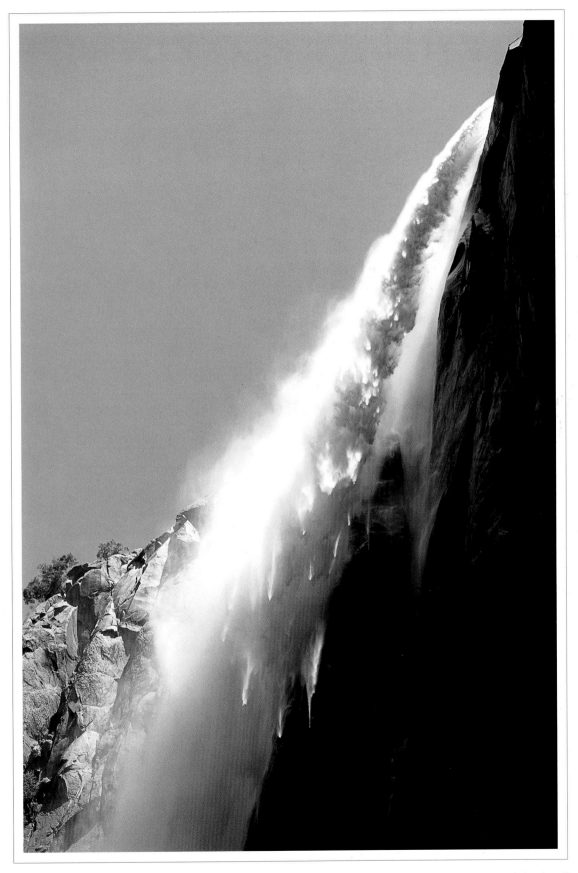

Streaming comets at Bridalveil Fall

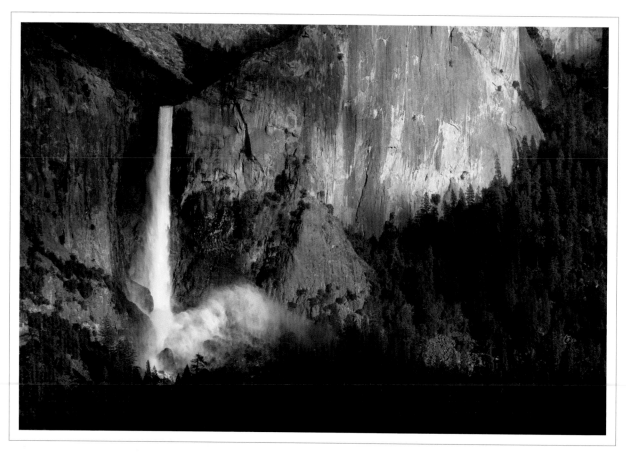

Bridalveil Fall. Photo by Michael Frye.

than a mile into the Valley—through which Bridalveil Creek descends from the upland to the brink of the cliff. This precipitous chute, cut by the creek prior to glaciation, was protected from the ravages of the glaciers by the immensity and solidity of Cathedral Rocks. It is the most important relic of the pre-glaciation era still existing in the Valley. Attractively flanked by Lower Cathedral Rock and the Leaning Tower, which form the walls of the gulch, Bridalveil Fall plunges six hundred twenty feet from the lip of the cliff to the floor of the Valley. One can appreciate the trough-like nature of Bridalveil Gulch from the Rockslides Trail on the opposite side of the Valley.

Although greatly swollen by spring runoff, Bridalveil retains its slender and graceful appearance because the stream flow is not churned up as it slides over the smooth lip of the fall. Another nota-

ble attraction of this fall is its rainbow display. As Muir observed, "The rainbows (or rather the spray-bows) of Bridalveil are superb, because the waters are dashed among angular blocks of granite at the foot, producing an abundance of spray of the best quality for iris effects." Occasionally, when mist is plentiful, a perfectly circular rainbow is formed. To be treated to this glorious sight, however, one must be completely immersed in the spray; all who have seen it report that it is well worth the soaking. After a particularly florid description of the Bridalveil rainbows, Hutchings commented, "At other times it is simply an enchantingly charming and graceful waterfall; but when lighted up by the afternoon's brilliant rainbows, a halo of glory seems to surround it." Because the fall directly faces the northwest, it is perfectly situated to catch the setting summer

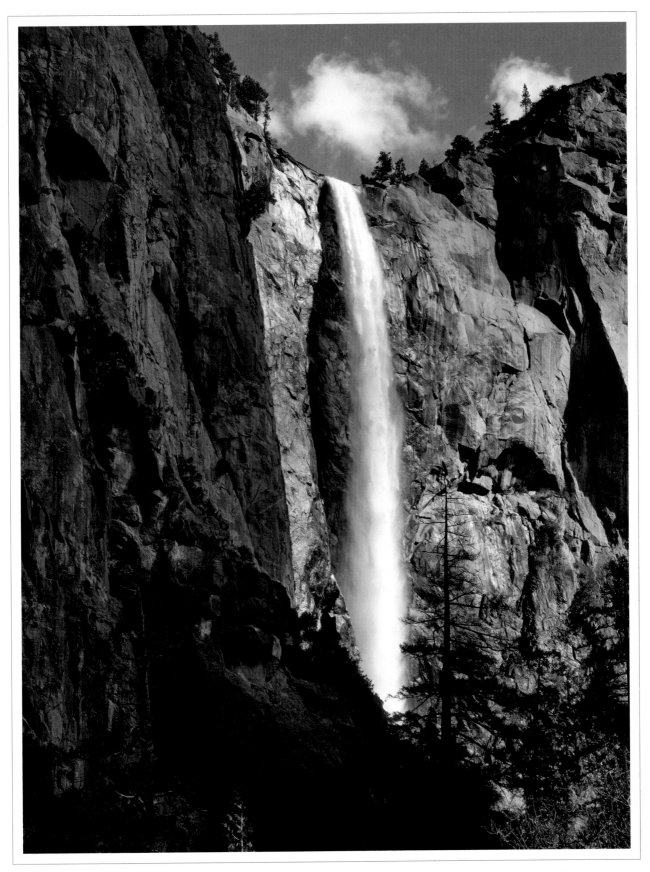

Bridalveil Fall. Photo Charles Cramer.

sunlight for the best rainbow effect. As with Illilouette, this fall is more appealing to some in late summer when the water, reduced in volume, is buffeted by the wind into what Hutchings described as "gracefully undulating and wavy sheets of spray, that fall in gauze-like ethereal folds...glittering in the sunlight, like a veil of diamonds." Others prefer Bridalveil in the full rush of its springtime glory. It is especially nice during this time of year at midday, when the sun is just high enough above the cliff to illuminate only the fringed edges of the curling spray.

Hutchings wrote that he and Ayres named Bridalveil Fall on their first trip to Yosemite. Bunnell, however, claimed that the fall was named by Warren Baer, editor of the *Mariposa Democrat* newspaper, on a trip they had made together to the Valley. The Indian name for this fall and its creek was "Po-ho-no." Although Bunnell was unable to "obtain the literal signification of the word," he believed it to be the name of a plant that grew in the creek basin. Hutchings, of course, had his own interpretation and said that Pohono was the Indian name of an evil spirit who lived in the waterfall. The source of the legend was supposedly the localized windstorm, called the "Pohono Wind," that strikes the area at night. Colder air gathering in the uplands above the Valley flows, much as the water does, down Bridalveil Gulch and spills over the cliff causing a rush of air that violently sways the shrubs and trees at the base of Bridalveil Fall. Hutchings believed that this wind was responsible for the belief in a spirit filled with an "angry enmity to the Indian race." Even so, the mysterious winds did not prevent the Indians from using areas surrounding this fall (and also Lower Yosemite Fall, which experiences similar winds) as village sites.

The watershed of Bridalveil Creek is about twenty-five square miles in area and largely forested. Because its moderately large watershed was never glaciated it has especially deep soils. The soil retains so much water that Bridalveil is Yosemite's only tributary waterfall that typically does not go dry by autumn. Bridalveil is also distinguished from the other falls (except Vernal) by maintaining its free-leaping nature all year, arching away from the cliff face even in times of low water.

There are many magnificent views of Bridalveil Fall, but the best are from Tunnel View, the road turnouts on both sides of the river adjacent to the fall and, especially, from the short trail leading to the base of the fall.

The Giant Stairway

Vernal and Nevada Falls, the two great waterfalls of the Merced River, pour over the two most perfectly crafted glacial steps in the Sierra. Called the Giant Stairway, these steps are but the lower portion of a larger glacial staircase that extends twenty-one miles up the Merced River Basin to the Sierra crest and boasts numerous cascades and waterfalls. The Merced River Basin above Nevada Fall contains sixty-seven high-country lakes and drains an area of 118 square miles. The watershed is roughly twice the size of Illilouette's and supplies more than enough water to make these two waterfalls regal in their presentations.

Although it is not apparent to a hiker on the Mist Trail, from Glacier Point anyone can easily see that these two falls are at a right angle to each other. From this bird's-eye perspective it is apparent that the falls flow in different directions because two master joints, which also lie at right angles, control their positions. Also associated with each fall (and step of the stairway) is a constriction of the canyon walls with a shallow basin scooped out of the tread (valley) behind it. The valley becomes narrowed because of obstructions that blocked ancient glaciers: the massive rock of Panorama Cliff on the south, and Half Dome, Mt. Broderick, and Liberty Cap, the three prominent domes to the north. As the glaciers hit these impediments, they dug in behind them creating the basins. Behind Nevada Fall is the glacial basin in the tread of Little Yosemite

Valley, which has been filled in by sediment, giving that valley a flat, sandy floor; behind Vernal Fall is Emerald Pool, which, unlike some of the glacial basins on the steps above and below it, has not been filled with sediment because the momentum of the spring flood carries all the sand and gravel with it. Like nowhere else in Yosemite, the views of the Giant Stairway from Glacier Point dramatically demonstrate that the location and structure of the waterfalls are determined by the underlying geology.

A word of caution to those unfamiliar with the hazards of wilderness hiking: the canyon between Nevada Fall and Yosemite Valley can be very dangerous. The spray and mist from the waterfalls and from the river itself coat the rocks along the riverside and make them very slippery. People are seriously injured or killed here almost every year. Please stay on the trails and avoid wet rocks near the river.

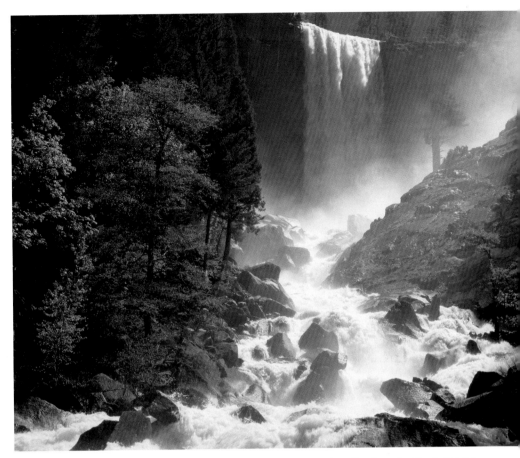

Vernal Fall. Photo by Keith Walklet.

Nevada Fall

Nevada Fall, the mightiest cataract in the Sierra, pours 594 feet over the upper step of the Giant Stairway. From its tranquil meanders in Little Yosemite Valley, the river surges through a rough-notched channel at the brink, from which it is dashed to foam. Arriving at the lip of the step, observed Muir, the stream "plunges over the brink of the precipice as if glad to escape into the freedom of the air. In this fall the water does not seem to be under the domination of ordinary laws, but rather as if it were a living creature, full of the strength of the mountains and their huge wild joy." Bunnell says that the Indian name for this fall was "Yo-wy-we, signifying the 'wormy' water, from the twist or squirm given to the water in falling upon an obstructing rock." He renamed it Nevada Fall ("nevada" being Spanish for "snow") because "the white, foaming water, as it dashed down Yo-wy-we from the snowy mountains above, represented to my mind a vast avalanche of snow."

The prominent notch in the massive granite step between the top of Nevada Fall and Liberty Cap was cut into a zone of vertical fractures by the Merced Glacier. As it offered the only practical route to the top of the fall, a hiking trail was built through this notch. During the time of highest water, however, the river originally gave off a small part of its

69

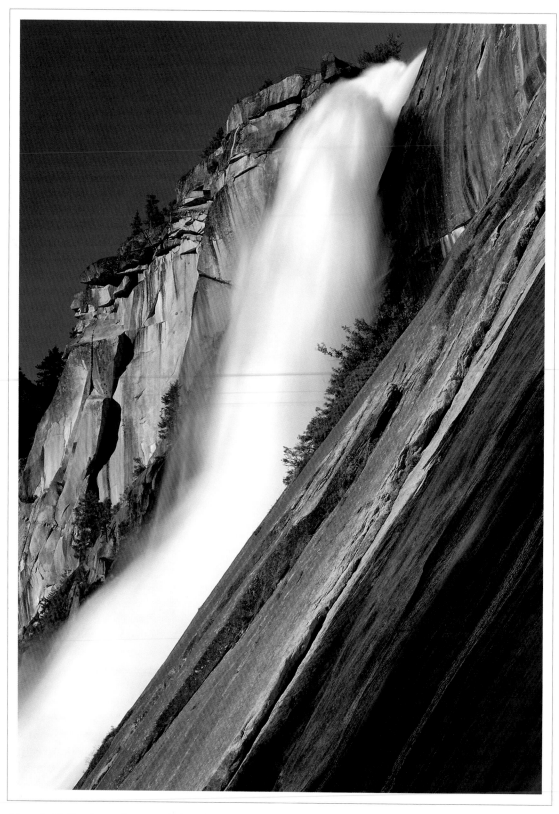

Nevada Fall in late afternoon light. Photo by Keith Walklet.

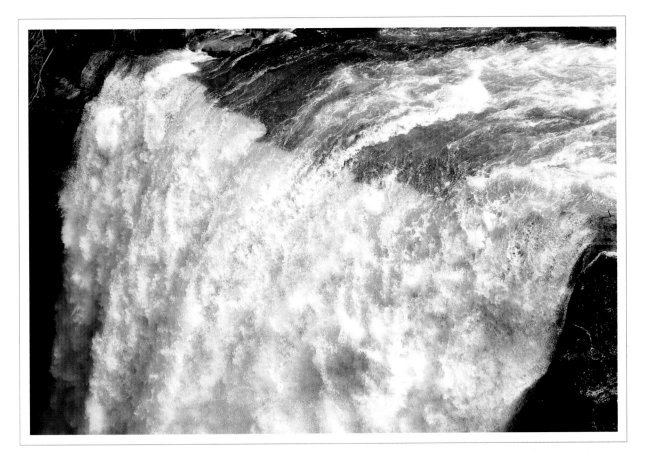

Lip of Vernal Fall

volume in overflow to form a cascade down this narrow, boulder-choked gully, and in order to save the trail from annual washout, the Yosemite Commissioners in the early 1870s had a small rock dam constructed above the notch to confine the river to its main channel. Infuriated by this action, Muir accused them of regarding the cascade at Liberty Cap "as a waste of raw material, a damaging leak that ought to be stopped up by a dam compelling all the water to tumble and sing together." It seems clear, however, that the purpose of the dam was to protect the trail.

Below Nevada Fall, the water gathers into a roaring torrent, and then with a tremendous rush passes through a narrow gorge. Shooting out of this gorge, the river plunges over a granite bench forming a small fall called Diamond Cascade because of the profusion of sparkling drops tossed into the air by the turbulent current. This bench represents the upstream side of the prominent joint running between Liberty Cap and Mt. Broderick; the rock of the downstream side was quarried away by glaciers. It was on the top of this bench that innkeeper Albert Snow built his La Casa Nevada Hotel in 1870.

From Diamond Cascade, wrote Matthes, "the river rushes with amazing speed down a gentle incline of smooth granite and spreads into a broad, thin sheet" called the Silver Apron. An obstruction in the streambed here creates a waterwheel, much smaller but more perfectly formed than the one on Snow Creek Falls, and visible from much closer. Take care to keep off the slippery rocks and out of the clutches of the racing current, however, lest you end up like the British visitor staying at La Casa Nevada

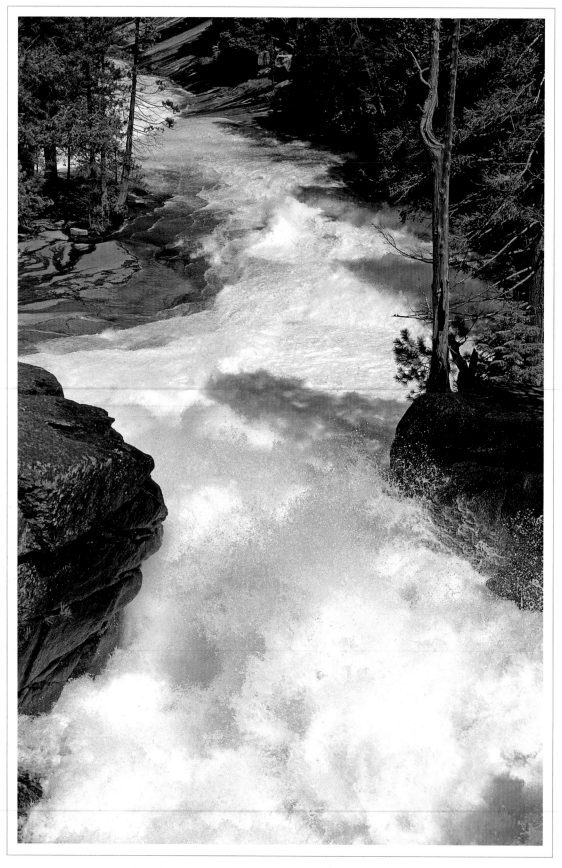

Diamond Cascade and the Silver Apron

who "thought it would be a delightful place to take a bath." He was immediately "knocked off his pins" and swept swiftly into the pile of rocks guarding the entrance to Emerald Pool. Fortunately no bones were broken and he was able to pull himself out, battered and bleeding but still alive. Unfortunately, this same scene is still reenacted on hot summer days, mostly by people who, unaware of the danger, slide down the Silver Apron for the thrill of it.

Vernal Fall

At the lower end of the Silver Apron, the Merced River enters the deep green and usually placid Emerald Pool, and from there it bounds through a short rapids and then over Vernal Fall. "The Glacial step at Vernal Fall is neatly squared and its front is essentially vertical and straight," wrote Matthes. Unlike most of Yosemite's falls, which are quite slender, the form of this step spreads the river out so that it goes over the brink in a broad sheet about eighty feet wide. "Vernal is an orderly, graceful, easy-going fall, proper and exact in every movement and gesture," wrote Muir. Dropping 317 feet, it is "a superb apron of embroidery, green and white, slightly folded and fluted, maintaining this form nearly to the bottom, where it is suddenly veiled in quick-flying billows of spray and mist, in which the afternoon sunbeams play with ravishing beauty of rainbow colors." According to Bunnell, the Indians called Vernal Fall "Yan-o-pah—little water cloud." The luxuriant plant growth nourished by the mist at the base of the fall and "the sun shining through the spray as in an April shower, suggested the sensation of spring before the name Vernal occurred to me." He took the name from a poem by Lord Byron.

The plentiful spray generated by Vernal Fall has made it the most popular of Yosemite's falls for rainbow watching. "No need here to travel for the magic rainbow end....It follows you, it trips you up, it tangles itself around your feet," wrote author Helen Hunt Jackson over a century ago. At the base of the fall she and her friends "went into a carnival of light. Rainbows rioted everywhere and we were crowding and jostling through as we could. The air was full of them, the ground danced with them, they climbed and chased and tumbled mockingly over our heads and shoulders and across our faces....They wheeled and broke into bits and flew, they swung and revolved and twined." In addition to regular garden-variety rainbows, it is occasionally possible, during the spring runoff when the mist is most plentiful and the sun is high, to see a perfectly round rainbow.

The trail to the top of the fall goes through the spray and is accordingly called the Mist Trail. Although hiking through the blasting spray is intimidating to some, the experience is both exhilarating and rewarding. The climb up the stone steps below Vernal is enhanced by lush greenery, blue sky, iridescent rainbows, and ever-changing perspectives of the fall. Originally, visitors were obliged to climb the final thirty feet of the headwall by way of a rickety wooden stairway called "The Ladders." The stairway was located at the top of the stone steps in the alcove where the south side of Vernal Fall's step abuts the canyon wall. Another of Yosemite's

"The Ladders," original trail to the top of Vernal Fall.
Courtesy Yosemite National Park Museum.

descends rapidly through a channel choked by huge boulders of broken rock. Its tributary, Illilouette Creek, joins the river before rounding the base of Grizzly Peak. At the bottom of the Giant Stairway is Happy Isles, so called by W. E. Dennison, an early Guardian of Yosemite, because "no one can visit them without for a while forgetting the grinding strife of this world and being happy." Here the river slows down, to work its way, meandering, through the nearly level floor of Yosemite Valley, augmented by flow from the other waterfalls along the way.

Yosemite Falls

Saving the best for last: no attraction in Yosemite Valley has more popular appeal than Yosemite Falls. "Surpassing all the other falls in height and splendor is Yosemite Falls," wrote Matthes. "It seems fitting that they should bear the name of the Valley, for they are easily the most spectacular scenic feature here. Even more than El Capitan and Half Dome they have given Yosemite its wide renown." It was a newspaper account of a waterfall a thousand feet high that first attracted Hutchings's interest, and it was Ayres's sketch of this fall that accompanied the *Hutchings'* magazine article that introduced Yosemite to the world.

Yosemite Falls has such enormous proportions that its true dimensions are hard to appreciate. It was this massive scale that made Ayres's drawing so popular and prompted early tourists to make the difficult horseback trip to see the wonder for themselves. Upon noticing that distant views didn't diminish its apparent size, an 1884 visitor wrote, "I began to understand something of the size of a fall to which a mile east or west matters so little." With a combined height of 2,565 feet, there are three stages of Yosemite Falls: the 1,430-foot Upper Fall, a Lower Fall of 320 feet, and an intermediate chain of cascades in a deep, quarter-mile gorge connecting the two. Yosemite Falls' geologic structure is dictated by the vertical joints that have given the falls their nearly perpendicular cliffs, and by two

Thomas Ayres's sketch of Yosemite Falls. Courtesy Yosemite National Park Museum.

frost-carved recesses, its fractured rock offers the shady, moist habitat favored by ferns. Hutchings called it Fern Grotto but most of the accessible ferns have been picked as souvenirs by hikers. As more visitors began to use the trail, the wooden staircase was replaced by a narrow ledge that was blasted out of the cliff face up to the top of the fall.

As spectacular as the scenery from the top of Vernal is, most prefer the view from below. Galen Clark, the first Guardian of Yosemite, liked best the view from Lady Franklin Rock—a large, flat rock projecting into the river a couple of hundred yards below the fall. This rock was named in honor of the wife of Arctic explorer Sir John Franklin, who was herself borne upon a chair litter to this famous view of Vernal Fall in the early 1860s.

From the base of Vernal Fall, the Merced River

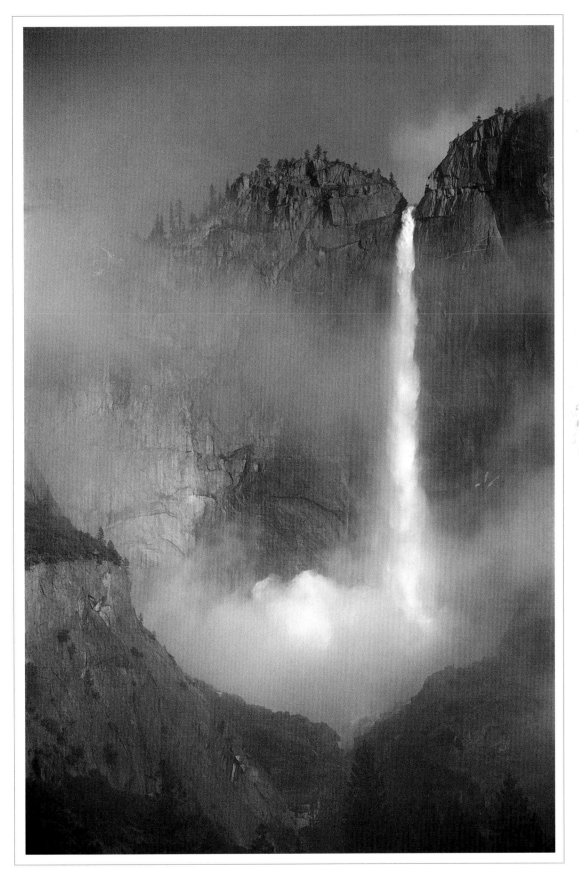

Upper Yosemite Fall, clearing storm

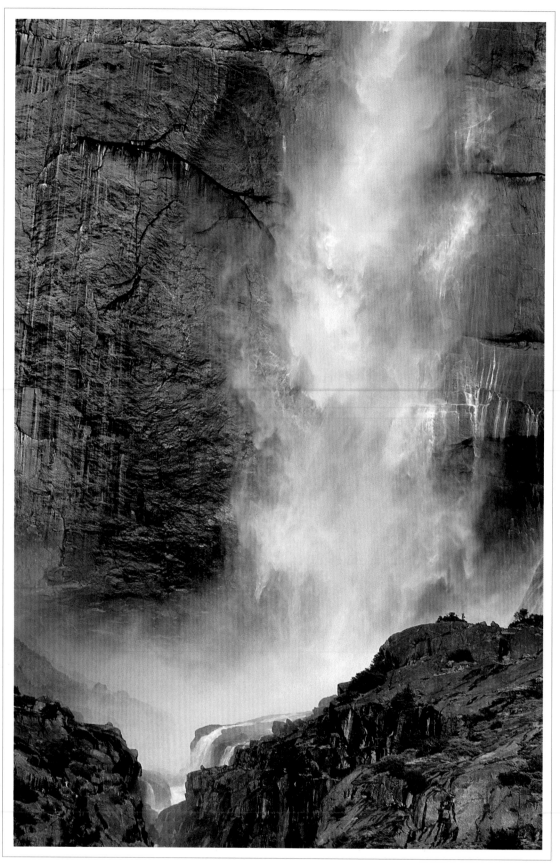

Upper Yosemite Fall, rainbow light

prominent horizontal master joints. Identified by lines of brush and live oak trees, the higher horizontal joint marks the base of the Upper Fall, while the lower joint determines the top of the Lower Fall. The inner gorge is carved into the rock between these two horizontal joints.

With a watershed of forty-three square miles, the hanging valley of Yosemite Creek is the largest on the Valley's north side. It stretches for ten miles across the upland to its headwaters on the north and west slopes of Mt. Hoffmann. This repeatedly glaciated drainage is a landscape of "polished surfaces,

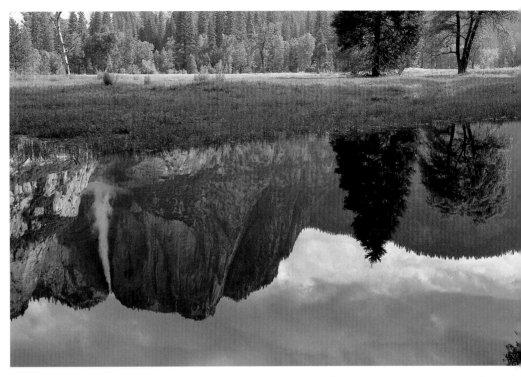

Meadow Reflections, Upper Yosemite Fall

paved with domes and smooth, whaleback masses of granite," wrote Muir, who first studied it while herding sheep across the range in 1868. For most of its length, Yosemite Creek has a remarkably smooth gradient, but about a mile back from the brink, it contracts into a narrow, rugged gorge. The glaciers shaving the face of the Upper Fall cliff truncated this gorge to leave the notch at the top of the cliff through which the Upper Fall now pours.

Most of the snow feeding the creek in this south-facing valley lies at a moderate elevation where the warmer temperatures promote faster melting. And since the thin soils of the drainage have a low water-retention capacity, the runoff proceeds rapidly. According to Matthes, in early summer the swollen creek gives Yosemite Falls "a magnificence unequaled by any other fall on this continent." As a result of the rapid depletion of the snowmelt, the falls are typically a mere trickle by late summer and dry by early autumn. It was in August of 1859 that the distinguished newspaper editor Horace Greeley, on a

one-day whirlwind tour of the Valley, pronounced the dribbling fall a "humbug." He appreciated the wonder of Yosemite but was unwilling to spend the time necessary to understand its seasonal variations, of which the changing Yosemite Falls is perhaps the finest example.

Upper Yosemite Fall is so awesome that its proportions are difficult to comprehend. Imagine: the Eiffel Tower would only reach to the two-thirds mark, and you would have to count the Empire State Building's antenna for it to reach the top of this fall. To Muir, who risked his life more than once to feel and understand the scale and force of this fall, it resembled a "throng of comets, ever wasting, ever renewed…which burst forth in irregular spurts from some grand, throbbing mountain heart. Now and then one mighty throb sends forth a mass of solid water into the free air far beyond the others, which rushes alone to the bottom of the fall with a long streaming tail, like combed silk, while the others, descending in clusters, gradually mingle and lose their identity. The bottom of the

Ice cone at the base of Upper Yosemite Fall

fall is a hissing, clashing, seething, upwhirling mass of…spray, through which the light sifts in gray and purple tones, while at times…the whole wild and apparently lawless, stormy, striving mass is changed to brilliant rainbow hues, manifesting finest harmony." Apparent chaos transformed into an ultimate harmony makes the Upper Fall a fitting symbol of Muir's view of nature.

The sounds of waterfalls, which vary with distance, wind conditions, and season, were music to Muir. Of all the falls in the Valley, Upper Yosemite has the richest and most powerful voice, "its tones varying from the sharp hiss and rustle of the wind in the glossy leaves of the live oaks and the soft, sifting, hushing tones of the pines, to the loudest rush and roar of storm winds and thunder among the crags of the summit peaks."

Because of the Upper Fall's height, winds sometime cause it to undulate from side to side. Josiah Whitney described this dancing movement as being "indescribably grand, especially under the magical illumination of the full moon." When the fall is blown toward the west, water is often caught behind a large upright rock flake on the face of the cliff. Draining through a notch in this flake is a small subsidiary fall that appears to pour out of the solid rock itself and becomes an engaging counterpoint to the main body of the waterfall. A more unusual effect of the wind on this fall was noted by Muir: during a violent winter storm the water was "suddenly arrested in its descent at a point about halfway down, and was neither blown upward nor driven aside, but simply held stationary in mid-air, as if gravitation below that point…had ceased to act." Another effect of the wind, similar to the Pohono Wind at Bridalveil, sometimes happens around the base of Yosemite Falls. Cooler air flows from the uplands in the Yosemite Creek drainage, just as the water does, and spills over the cliff to gust boisterously among the trees and shrubs below. The tossing trees caught in this "Lost Arrow Wind" stand in stark contrast to those, nearby but outside the path of the blast, that stand quietly in the still night air.

Although Upper Yosemite Fall is in its glory in early summer, it is equally spectacular in its "winter robes." On cold nights, part of the falling water freezes against the cliff in a large triangle-shaped mass of "crystal plaster" extending the entire height of the cliff. Cracked off by the early morning sun, the falling ice can be heard booming and thundering throughout the upper end of the Valley. If temperatures remain cold during the winter the falling ice piles up in a huge cone-shaped mound at the foot of the fall, called an "ice cone." A photograph from

Muir's time shows an ice cone well over three hundred feet high. That was an exceptional cone, however, as most years it stays below two hundred feet.

Later, as temperatures warm, the waterfall drills a hole through the cone to shape a volcano of ice with a crater-like throat. Under the assault of increasing water volume and warmer daytime temperatures, the ice cone starts receding by March and has usually melted by April. An ice mound forms at the base of Ribbon Fall as well, but only Upper Yosemite Fall produces such a large and symmetrical cone. Unfortunately, the ice cone may be one of the early victims of global climate change as the warmer weather in recent years has produced much smaller ice cones.

An interesting feature of Yosemite Creek is often erroneously attributed to the ice cone. Occasionally, in early spring the stream from the base of the Lower Fall, through the braided channels and all the way to its confluence with the Merced River, becomes clogged with slushy ice. Many people assume this sudden appearance of ice results from the ice cone breaking up. Called "frazil ice," it is formed after a period of warm weather—which starts melting the snow and increases the flow in the creek—is followed by below-freezing temperatures. The falling water becomes supercooled and turns to ice when it touches the rocks in the streambed, and more ice crystals form as the movement of the creek slows until the slush overflows the banks and covers the entire area, often to a depth of several feet. In 1955 slush covered the area between the road and the Lower Fall to a depth of fifteen feet and had to be removed from the trails with snowplows. Frazil ice also occasionally forms on other creeks in the Valley below their respective falls, but Yosemite Creek always provides the most impressive example.

Almost as interesting as the Upper Fall itself are the surrounding cliffs. To the east of the fall is Yosemite Point, the highest part of the cliff and a great spot from which to view the Upper Fall and the Valley itself. Between the Upper Fall and Yosemite Point is the gigantic tapering rock monument called Lost Arrow

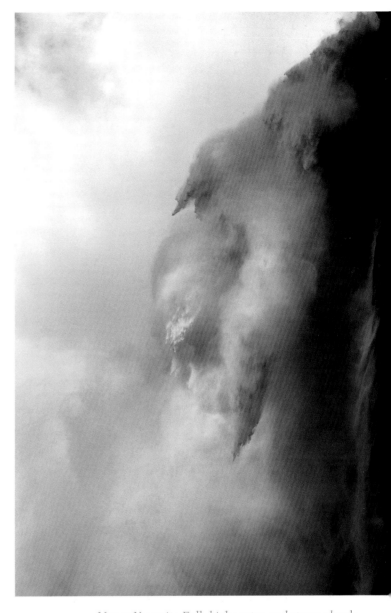

Upper Yosemite Fall, high water and storm clouds

Spire. This fifteen-hundred-foot-high projection is a remnant of a rock sheet that once extended across the entire cliff face. Stubs of several such sheets can be seen on the projecting buttress below Yosemite Point. The flake in the middle of the cliff just to the west of the fall (which traps water behind it to create the small fall mentioned above) is a remnant of another of these rock sheets. These remnants are reminders of the series of parallel vertical joints between them.

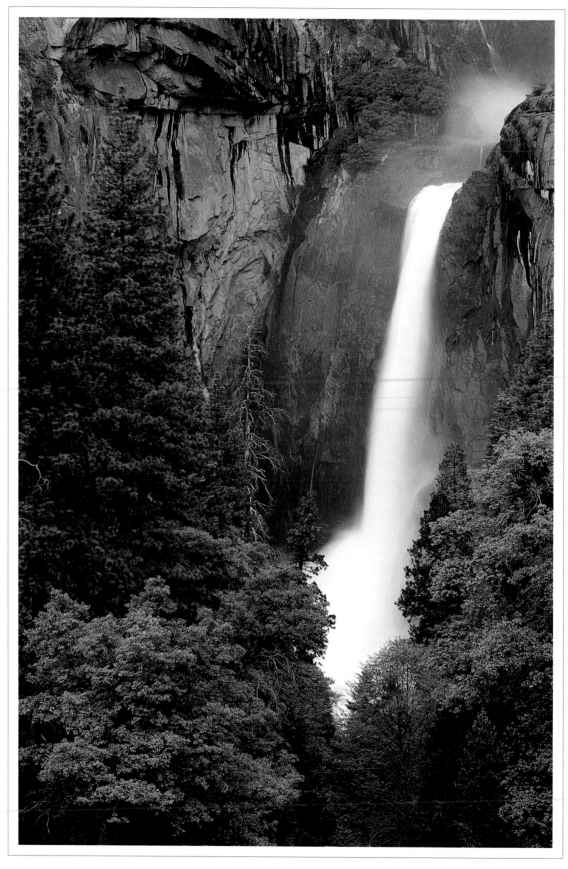

Lower Yosemite Fall, storm light

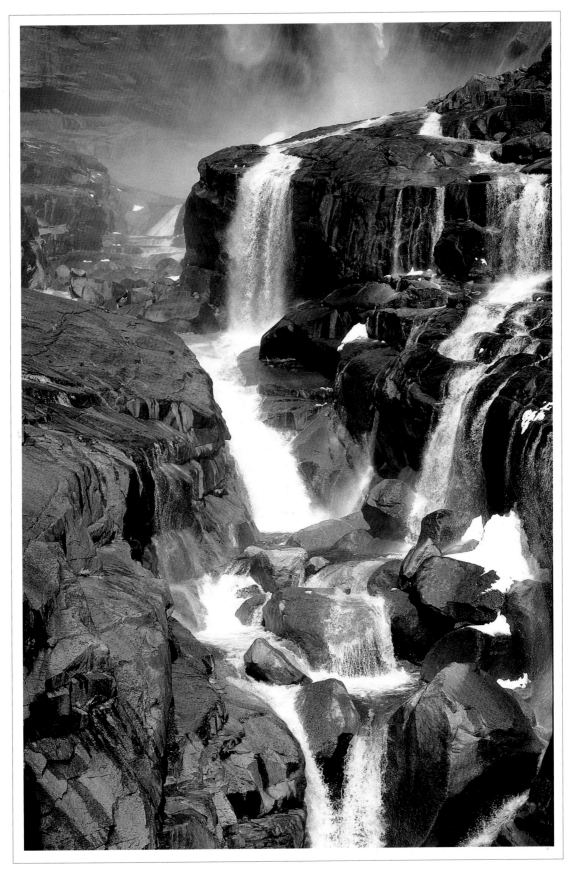

Upper part of Inner Gorge between Upper and Lower Yosemite Falls

Inner Gorge between Upper and Lower Yosemite Falls

in the gorge just above Lower Yosemite Fall. Small amounts of rainwater and snowmelt from the gully still follow the old route, and in spring and early summer you can see water flowing in this channel above and to the left of the top of Lower Fall. Yosemite geologist N. King Huber was able to locate the remains of an old moraine on the creek about a mile upstream from the Upper Fall, and it was this moraine that set the stream off in a different direction—one that led to the edge of the cliff and a free-leaping waterfall.

The best perspectives for viewing these associated features of the Upper Fall are from Glacier Point and the top section of the Four Mile Trail. The Upper Fall itself is best appreciated from the Yosemite Falls Trail and from the overlook at the top of the fall, although it is pretty spectacular from any place in the east end of the Valley.

Completing the leap over Upper Yosemite Fall, the dispersed spray is collected in a large, smooth, bowl-shaped depression at the base of that fall for its trip though the Inner Gorge between the Upper and Lower Falls. With a boisterous descent of 815 feet, the pools, rapids, cascades, and falls within this gorge form, in Muir's opinion, "a series more strikingly varied and combined than any other in the Valley." There are three actual falls in the gorge; the first about thirty feet, the middle about two hundred fifty feet, and the third perhaps one hundred twenty-five feet. Of the three, only the lowest is visible from the Valley, although with binoculars, glimpses of the others are possible from appropriate spots on the upper section of the Four Mile Trail. Perhaps it should be mentioned that the area around the base of the Upper Fall and the Inner Gorge is one of the most dangerous places in the park. It seems like every few years someone exploring among the wet and slippery rocks is injured or killed here. Please stay on the trail as you make your way to the top of the falls.

Bursting out of the Inner Gorge the creek plunges, again leaping free of the cliff, over the Lower Fall. Credited by Muir as having the best rainbows in the Valley, Lower Yosemite Fall has also become justly

The present face of the cliff is just the most recently exposed of the series of layered rock sheets.

To the west of the Upper Fall is the Yosemite Falls gully, the route the upper half of the trail follows to the top of the falls. This gully marks the original course of Yosemite Creek; in other words, at one time there was no Upper Yosemite Fall! Rather, the creek tumbled down the gully in what was undoubtedly a very attractive cascade. Below the gully, the deeply cut ancient stream channel joins the current creek

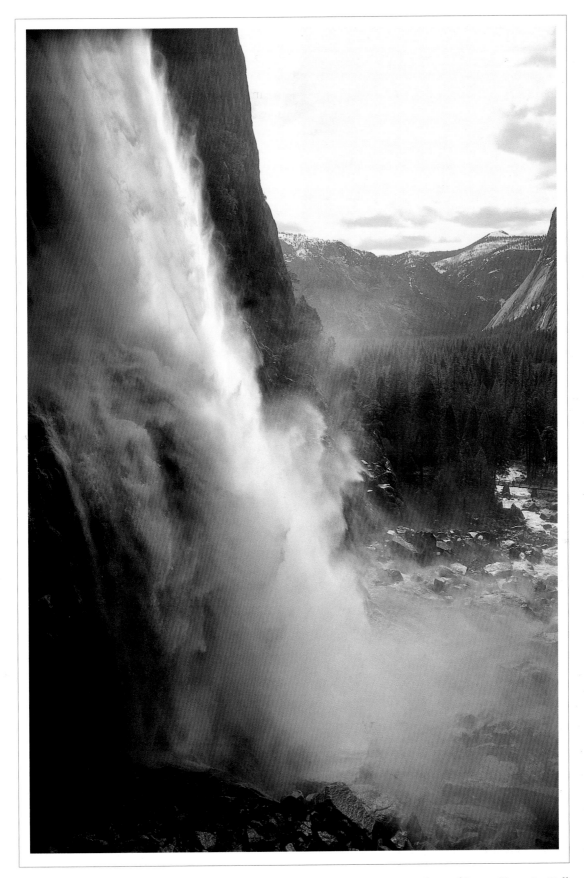

Base of Lower Yosemite Fall

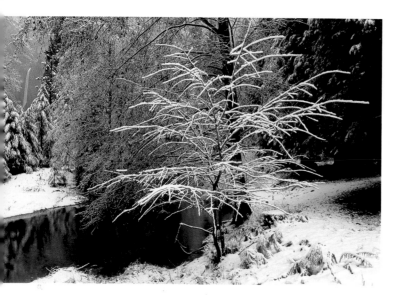

Lower Yosemite Fall

famous for its lunar rainbow, or "moonbow." In late spring, when the spray at the base of the fall is highest, the light of a full moon often casts a glowing arc over the raging torrent. For most observers the moonbow is a pearly white or opalescent color, but people with especially keen night vision occasionally report seeing faint colors. A slanted, projecting ledge near the bottom of the fall creates the abundance of spray that causes this unusual spectacle.

Like the alcoves of other falls, the recess into which the Lower Fall plunges has been eroded into a narrow zone where the rock is sheared by vertical fractures. Recently fallen angular slabs at the head of the alcove indicate that it is still growing. Aided by the spray and following the zone of weakness, the alcove has been enlarged for quite a distance beyond the waterfall itself.

Far and away the best place to enjoy Lower Yosemite Fall is from the bridge across the creek at its foot, where the blasting spray and the dancing light of its rainbow and moonbow create one of the Valley's most exhilarating experiences.

Since Yosemite Falls "appeared to be the principal one of the Sierra," wrote Bunnell, "I gave it the name of Yosemite Falls, and in so naming it I but followed out the idea of the Indians who called it 'Choo-Look' or 'Scholook,' which signifies, in this case, 'The Fall,' while the creek appeared to be known to some as 'Scho-tol-lo-wi,' interpreted to mean 'the creek of the fall.'"

Conclusion

The opportunity to view Yosemite Valley's celebrated waterfalls is high on the list of reasons people choose to visit the park. The falls are as impressive and inspiring to today's visitor as they undoubtedly were to the original inhabitants and the first tourists who came to see them. The only real difference between then and now is that today's visitors have available to them the knowledge of why the Earth is so adorned with waterfalls in this one spot. The earlier myth and mystery surrounding the waterfalls have only been enhanced by a sense of wonder at the amazing geological events that have given life to Yosemite's dancing waters.

It has been the aim of this book to acquaint waterfall-watchers with the full range of the Valley's plummeting streams. From the unnoticed to the world-famous, each offers appealing characteristics to be enjoyed by all who care to see. Hopefully, the reader's curiosity has been piqued to seek out and experience the waterfalls of Yosemite Valley from the perspective of his or her own life.

HEIGHTS OF YOSEMITE VALLEY FALLS

Bridalveil Fall 620'

The Cascades 500'

Illilouette Fall 370'

Nevada Fall 594'

Pywiack Cascade 600'

Ribbon Fall 1,612'

Royal Arch Cascade
 1,250'

Sentinel Falls 2,000'

Silver Strand Fall 1,170'

Snow Creek Falls 2,000'

Vernal Fall 317'

Wildcat Fall 700'

Yosemite Falls (combined)
 2,565'

Upper Yosemite Fall
 1,430'

Lower Yosemite Fall 320'

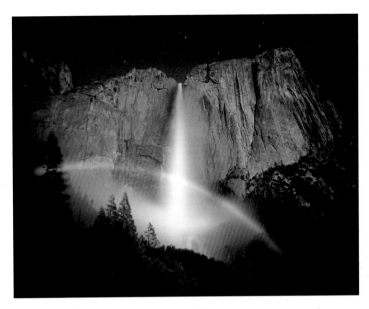

Lunar Rainbow, Upper Yosemite Fall

The heights given for the waterfalls are those provided by Francois Matthes; he did not describe the process he used to determine these heights. While instruments can provide fairly accurate readings between specific points, visitors should realize that deciding exactly where a waterfall begins and ends is highly subjective. For instance, the creek at the top of Upper Yosemite Fall slopes increasingly as it approaches the cliff face. Reasonable people could easily differ by a factor of many tens of feet in deciding where the "top" begins. The same can be said for where the "bottom" ends. This is true to a greater or lesser degree for all the falls, so the heights listed above, as well as in the text, should be considered ballpark figures instead of exact measurements. The author confesses to being mystified as to why, for instance, Ribbon Fall is listed in Matthes's records as 1,612' as opposed to about 1,600'. And while some falls seem to have been measured down to the last foot, others (like Sentinel Falls) are clearly estimates or approximations. Whatever the falls' actual heights, visitors are particularly keen to have this information. It may be that interest in the heights of the waterfalls is due to the fact that their sizes tend to be underestimated in the contexts of the grand scale of Yosemite's vistas. Everything here is bigger, taller, wider, grander than your initial estimate, and it may be that knowing the height of a waterfall provides a yardstick by which the rest of the scenery can be judged and appreciated.

In the author's opinion, height seems to be one of the least helpful statistics to know about a waterfall. What you feel, your actual experience, when directly engaged with a waterfall is what is important. The roar and boom in your ears, the feel of spray on your face and the thundering vibration in your feet, the visual banquet of light and motion—these are the true descriptive measures of a waterfall. In the final analysis, it is these impressions—not the height—that the visitor takes away.

A sometimes confusing aspect of waterfalls is whether to refer to them in the singular or plural. In some cases it seems to be decided by what sounds best by the speaker at the time. To establish consistency in this volume I have decided to go by the singular if the waterfall being discussed consists of one identifiable unit (such as Bridalveil Fall). If the flow occurs in multiple discernable and independent falls (such as Sentinel Falls), I have chosen the plural.

The Cascades from the Wawona Road

uir spoke once of seeing a "Specter of Brocken" from the summit of Half Dome. This is an atmospheric condition when, from a high perspective, the sun casts a person's shadow onto a layer of clouds below. In very rare circumstances, a circular rainbow or "glory" is projected onto the shadow of the viewer's head, centered on the shadow's eyes. Sometimes, as in this case, an even larger, although dimmer, rainbow surrounds the glory. In a row of spectators, each person will be able to see every other person's shadow, but the glory will always be centered on the shadow of the viewer himself. I have only seen this spectacle twice in my life in the mountains, and this photo captures the only time I saw the larger outer rainbow. It was particularly special that I was also able to include one of Yosemite's great waterfalls in the photograph.

Dedication and Acknowledgments

This book is dedicated to the memory of Steve Medley and N. King Huber, both giants in the intellectual life of Yosemite National Park.

Steve was by turns a ranger, librarian, lawyer, author, and, for many years, the president and heart and soul of the Yosemite Association. He guided YA through a period of unprecedented growth in its mission of providing interpretive and educational programs and publications supporting Yosemite. His vision and drive are clearly visible through the scope of books and other publications and the wonderful array of programs offered by YA. This legacy will benefit Yosemite for generations to come. He also was the friend who kept up patient, though persistent, encouragement for me to update and improve the waterfall book. King Huber, geologist emeritus of the U.S. Geological Survey, devoted much of his career to Yosemite and the Sierra. His love for Yosemite shone forth not only in his books and scholarly publications but also in his personal availability to park staff, interpreters, and instructors who sought him out to better learn the geologic story of Yosemite. He generously read my manuscript to make sure that I got it right. King had the ability to distill the complexity of geology into concepts easily understood by lay people while preserving the magic and beauty behind the science. King's work lives on through the efforts of those who learned so much from him. Both Steve and King were those rare individuals who accomplish much not only through their own work but also by how much they help others to succeed.

One measure of the true magnificence of Yosemite is the number of great photographers who work here on a regular basis. The visual appeal of this book has been much enhanced by the inclusion of the work of some of these photographers. I would like to thank my friends Steve Botti, Annette Bottaro-Walklet, Charlie Cramer, Michael Frye, Jeff Grandy, and Keith Walklet for the generous donation of their images for this project.

It takes a village to make a book and there are so many people who have provided encouragement and support during the process. For reviewing the manuscript and providing editorial comments I would like to thank Dave Forgang, Laura Kirn, Karl Kroeber, Penny Otwell, Jim Snyder, and Mary Vocelka. Thanks also to Malcolm Margolin and his professional staff at Heyday Books, especially acquisitions editor Gayle Wattawa, production editor Diane Lee, editors Lisa K. Manwill and Jeannine Gendar, and designer Lorraine Rath, for taking random photographs and ramblings and turning them into a coherent and imaginative book. Heyday Books has recently entered into an agreement to become the publishing arm of the Yosemite Association, and the collaboration of these two wonderful organizations can only bode well for the future of Yosemite publications. I am proud to have my book included in the vanguard of this new era.

And finally, although certainly not lastly, I would like to thank the Yosemite National Park research librarian, the lovely and talented Linda Eade. Although it was never my intention either to become an author or to marry a librarian, I have to say that it worked out well for me. Linda's assistance with the research for this book is but a fraction of the many ways in which she supports and nurtures my ambitions.

YOSEMITE
ASSOCIATION

The Yosemite Association is a 501(c)(3) nonprofit membership organization; since 1923, it has initiated and supported a variety of interpretive, educational, research, scientific, and environmental programs in Yosemite National Park, in cooperation with the National Park Service. Revenue generated by its publishing program, park visitor center bookstores, Yosemite Outdoor Adventures, membership dues, and donations enables it to provide services and direct financial support that promote park stewardship and enrich the visitor experience. To learn more about the association's activities and other publications, or for information about membership, please write to the Yosemite Association, P.O. Box 230, El Portal, CA, 95318, call (209) 379-2646, or visit www.yosemite.org.

HEYDAY
BOOKS

Heyday Books, founded in 1974, works to deepen people's understanding and appreciation of the cultural, artistic, historic, and natural resources of California and the American West. It operates under a 501(c)(3) nonprofit educational organization (Heyday Institute) and, in addition to publishing books, sponsors a wide range of programs, outreach, and events. For more information about this or about becoming a Friend of Heyday, please visit our website at www.heydaybooks.com.